Marjorie Sarnat's
Pampered Pets

Racehorse Publishing books may be purchased in bulk at special discounts for sales promotion, corporate gifts, fund-raising, or educational purposes. Special editions can also be created to specifications. For details, contact the Special Sales Department, Skyhorse Publishing, 307 West 36th Street, 11th Floor, New York, NY 10018 or info@skyhorsepublishing.com.

Racehorse Publishing™ is a pending trademark of Skyhorse Publishing, Inc.®, a Delaware corporation.

Visit our website at www.skyhorsepublishing.com.

10 9 8 7 6

Cover design by Brian Peterson
Cover artwork by Marjorie Sarnat

Print ISBN: 978-1-5107-1257-7

Printed in the United States of America

Marjorie Sarnat's
Pampered Pets

New York Times Bestselling Artists' Adult Coloring Books

MARJORIE SARNAT

Racehorse Publishing

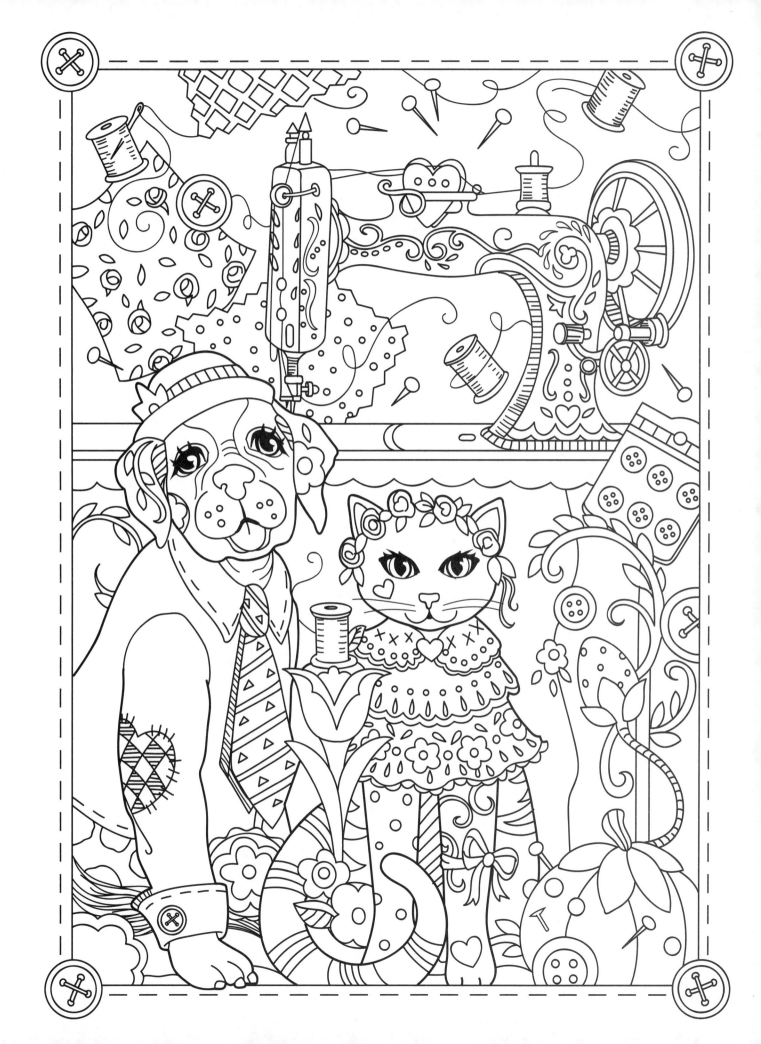

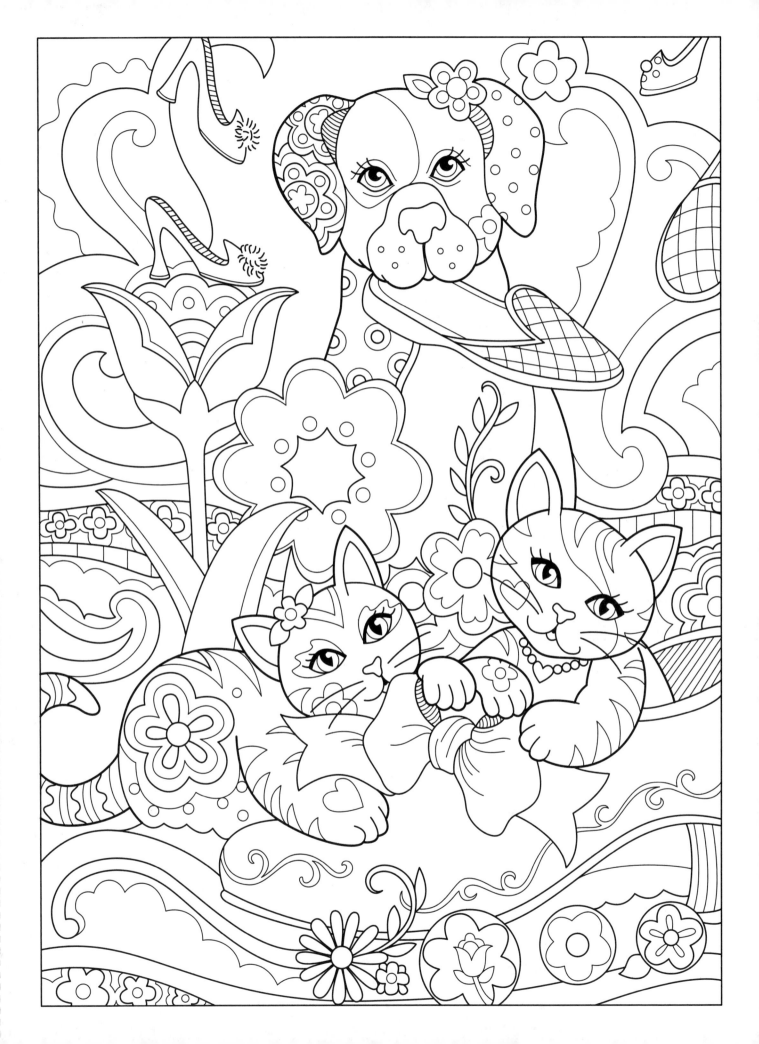

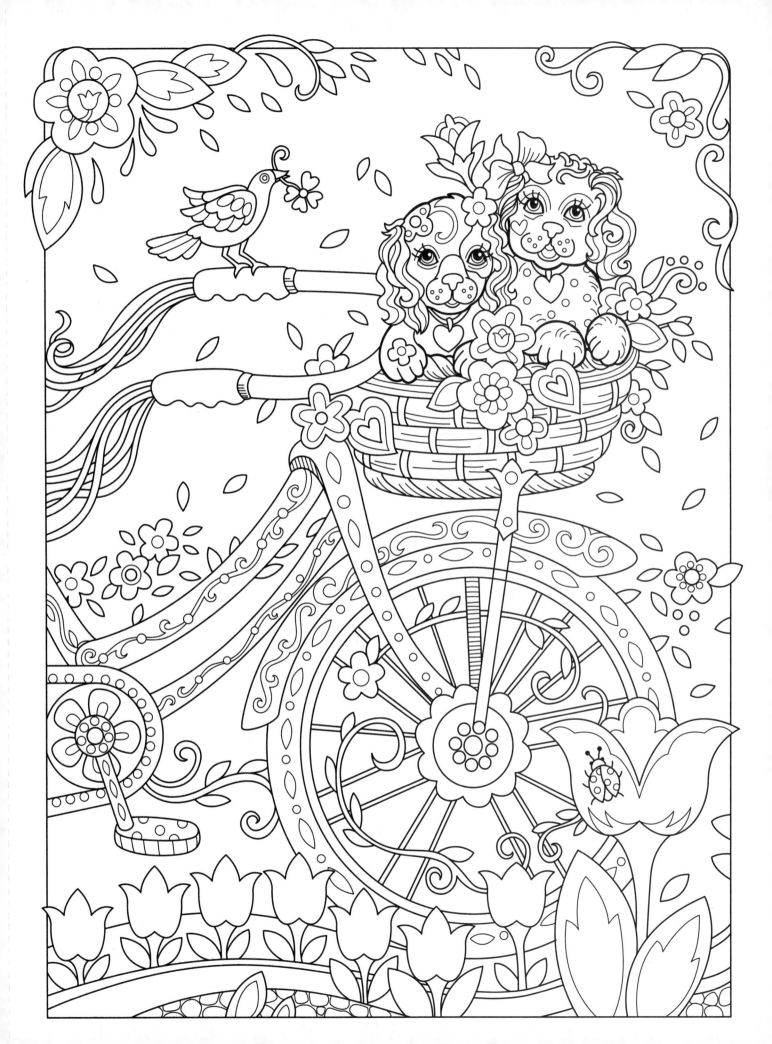

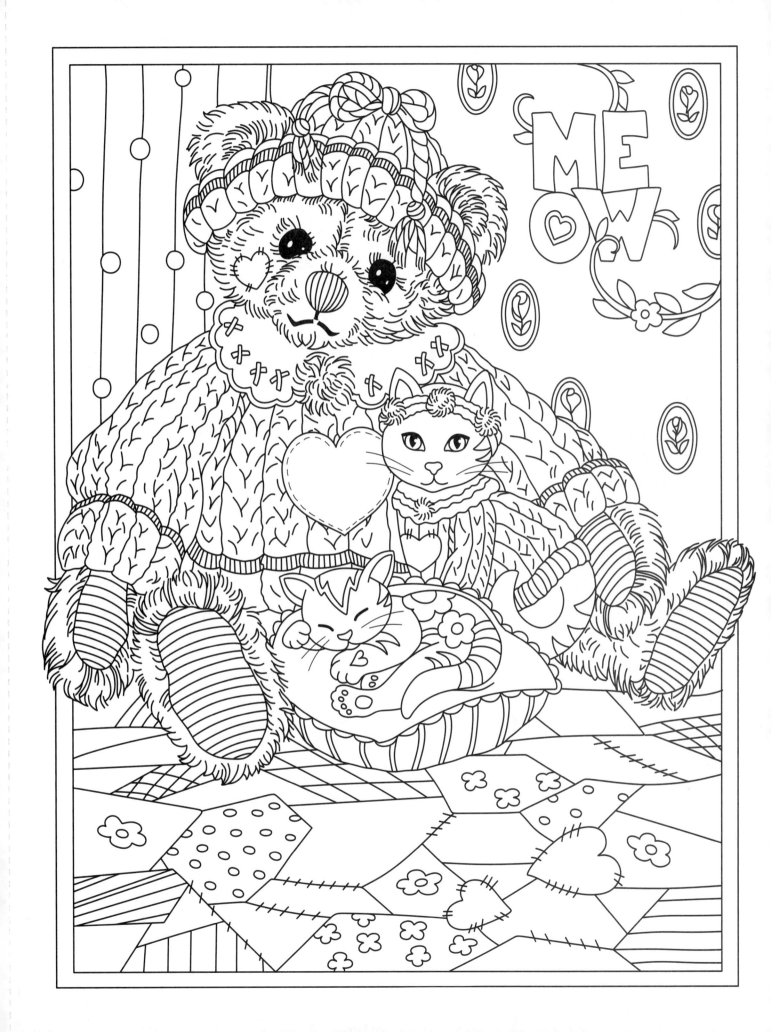

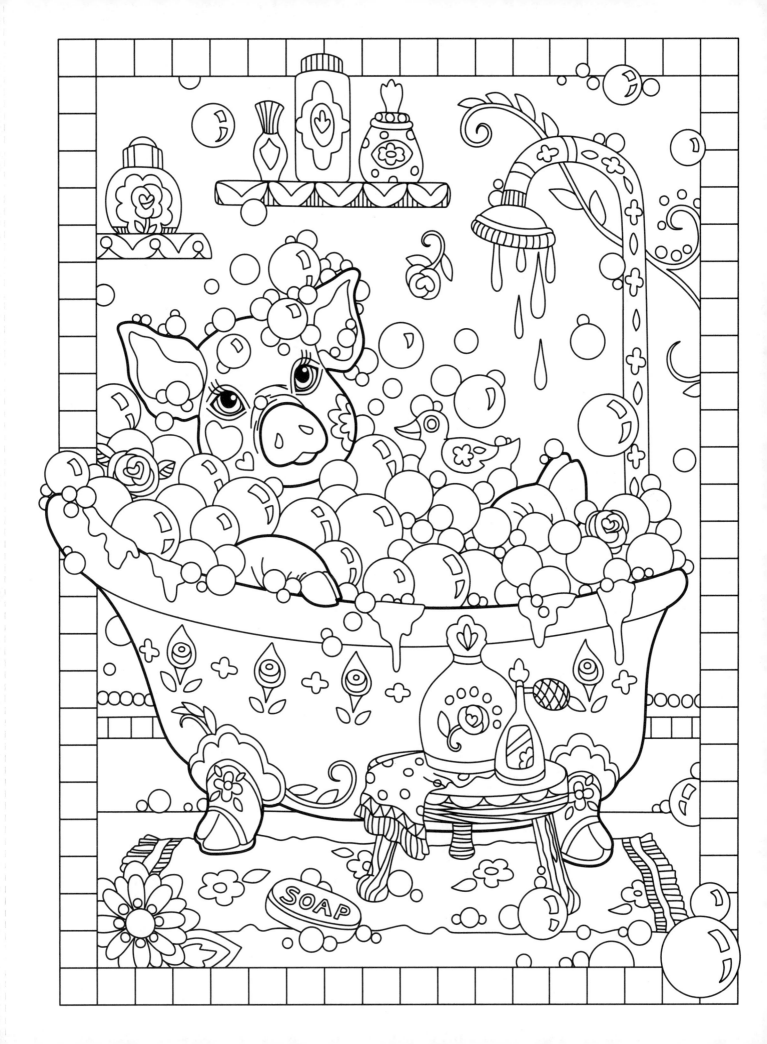

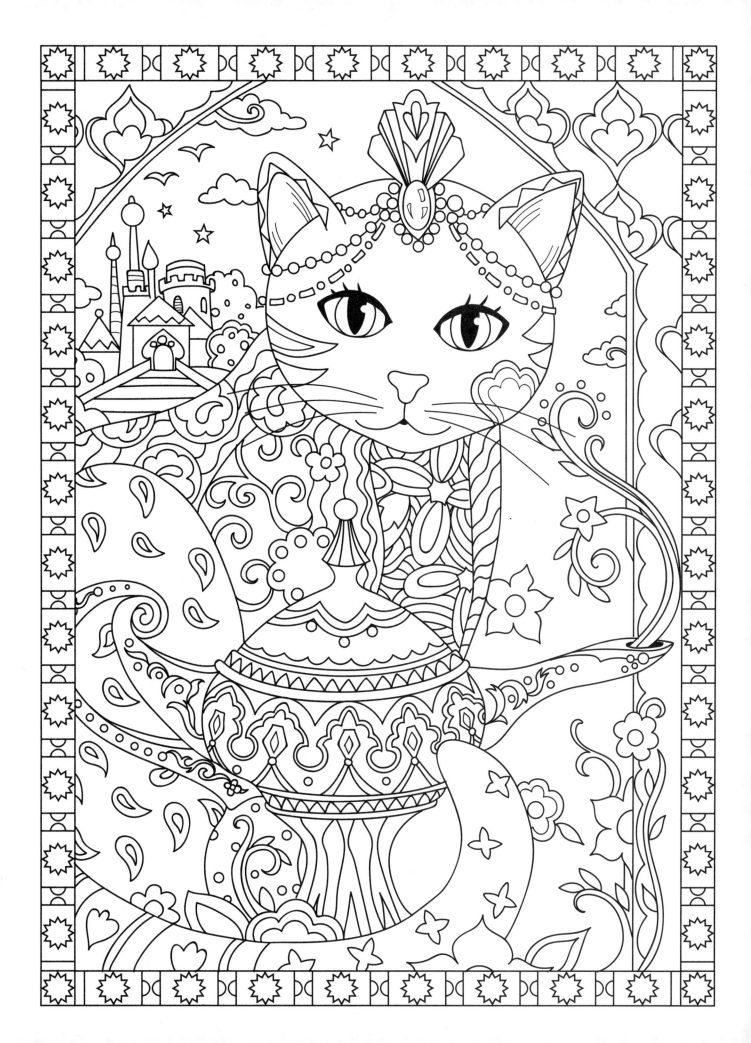

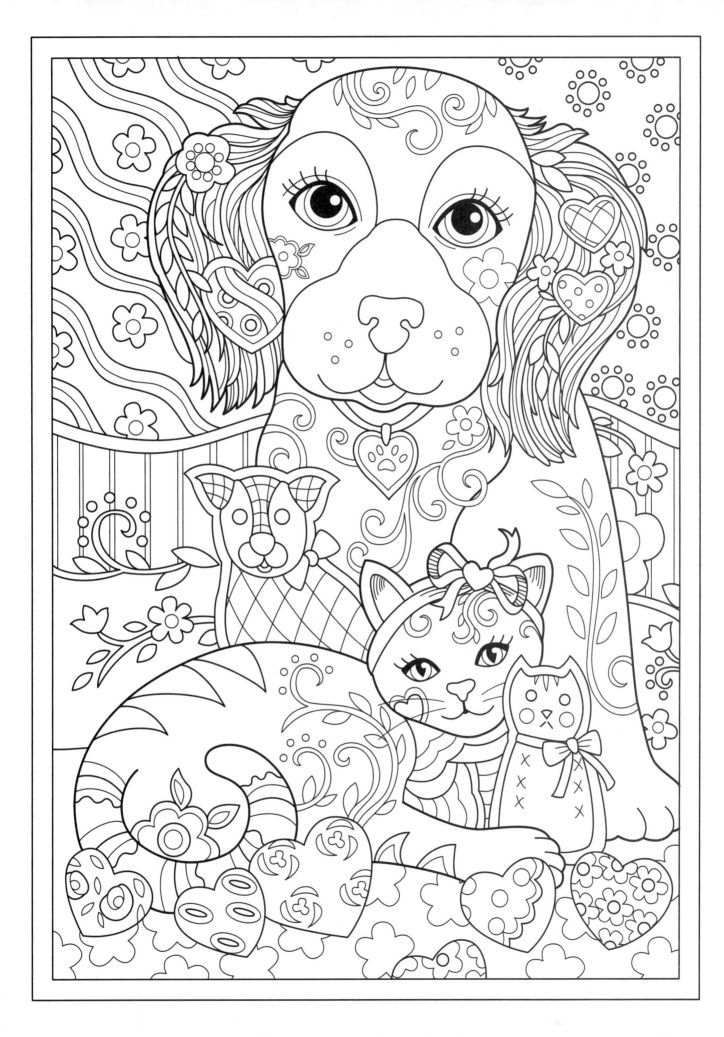

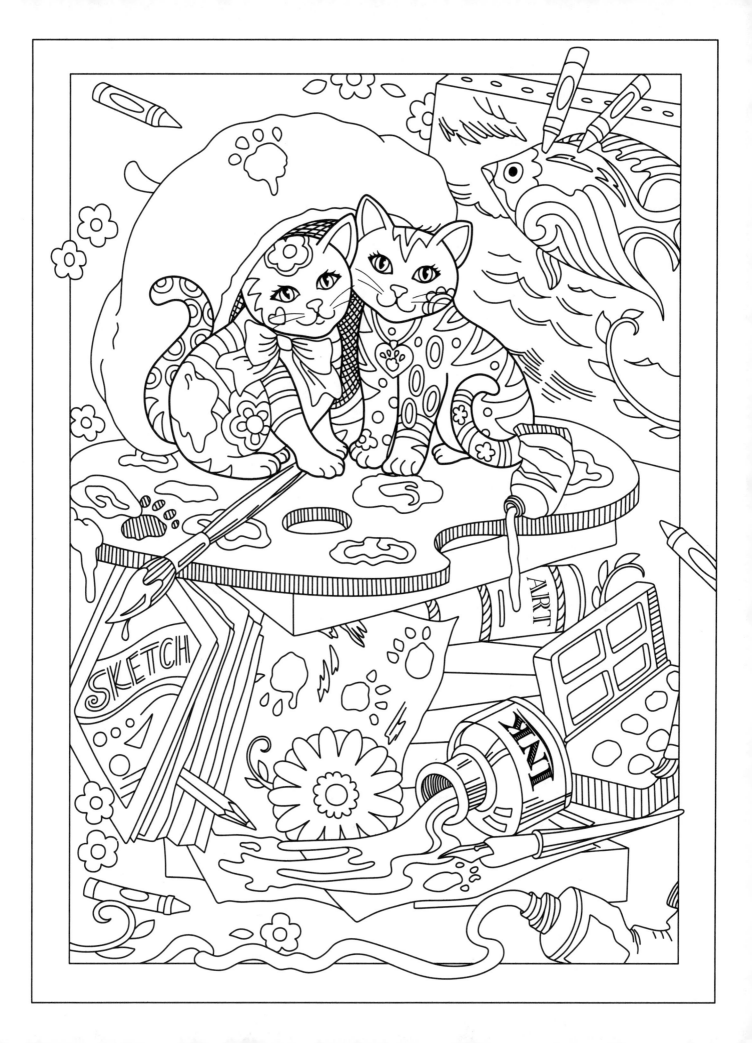

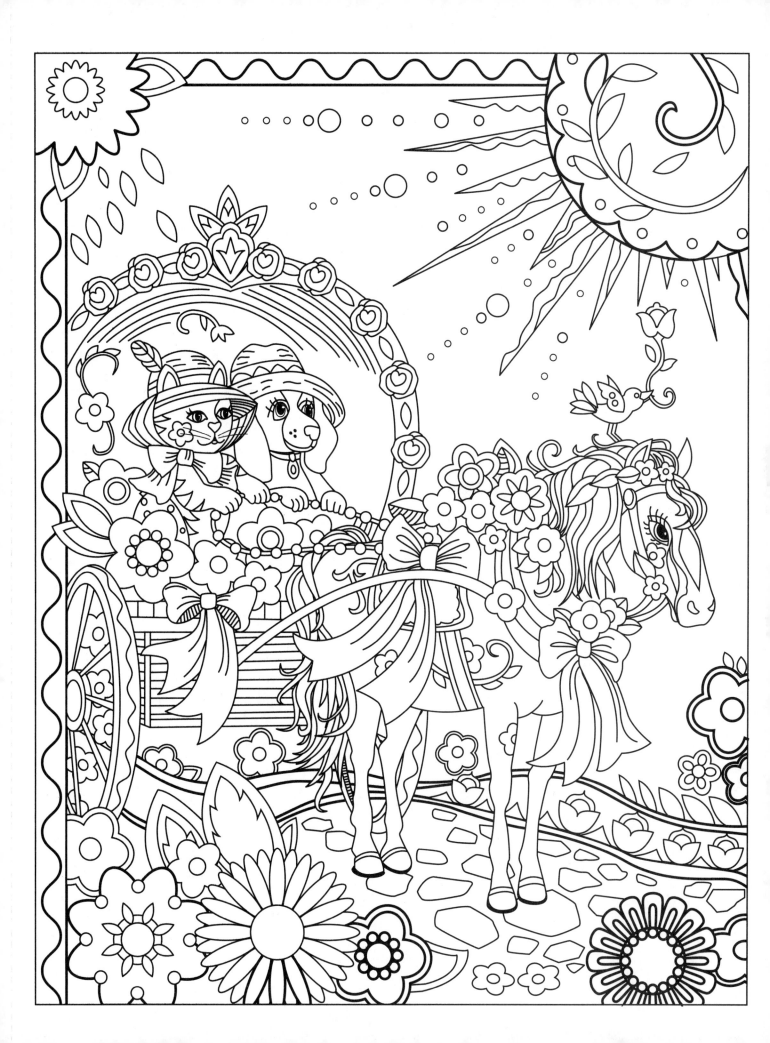

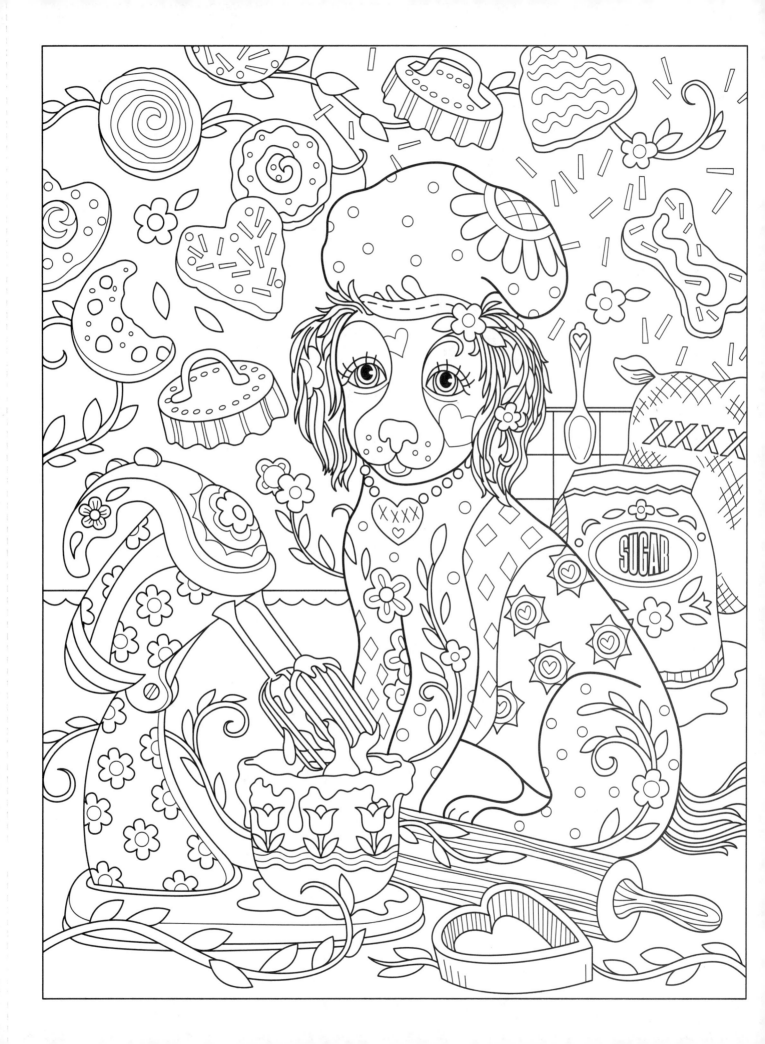

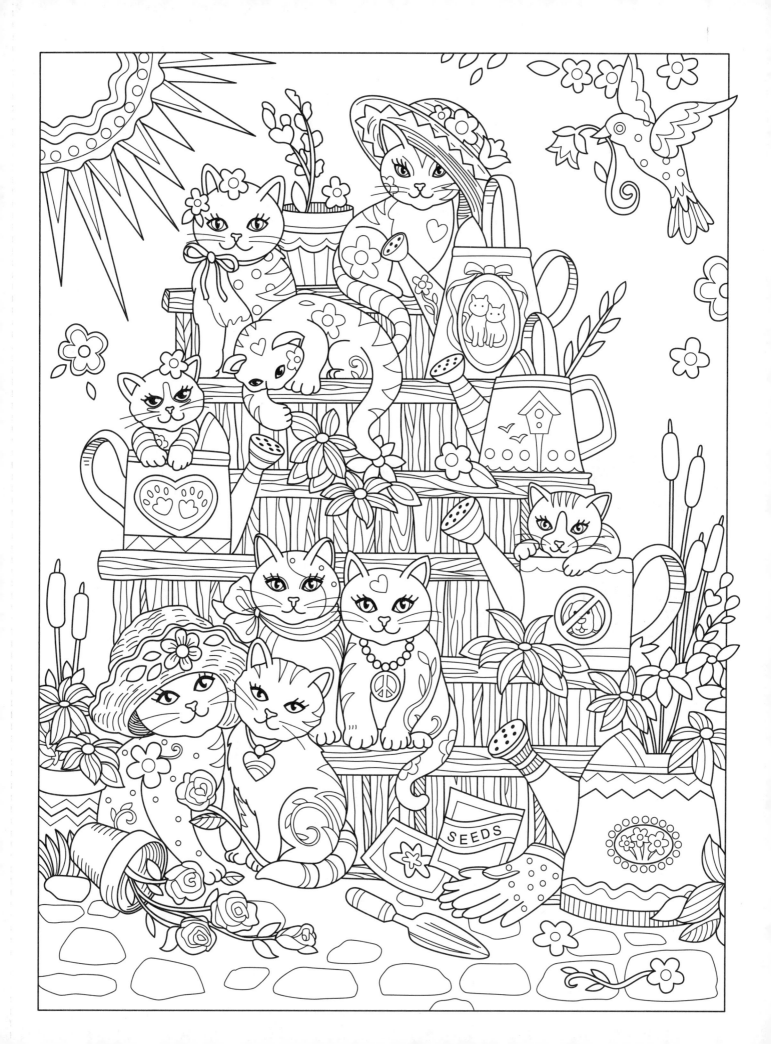

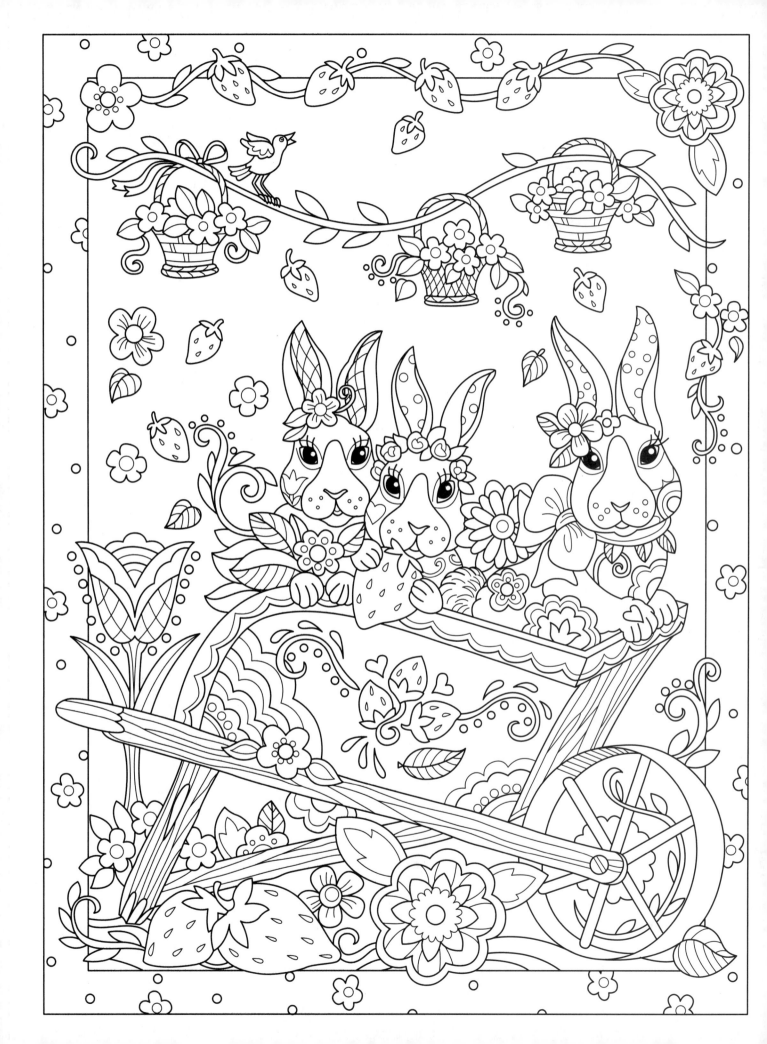

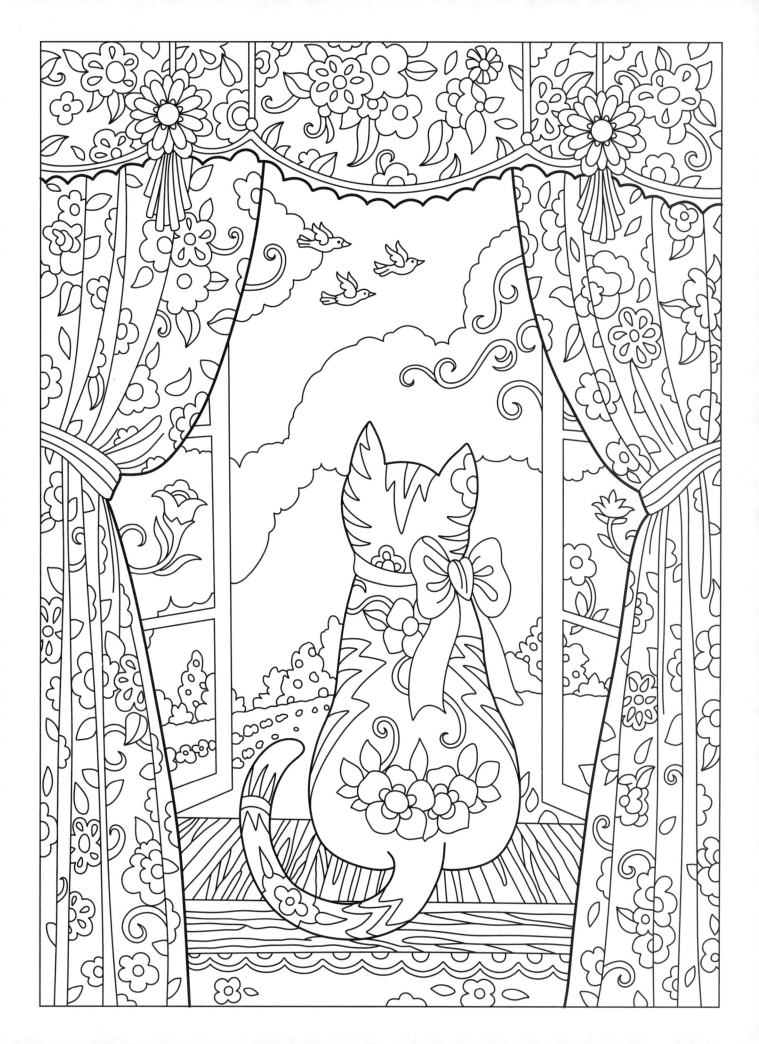

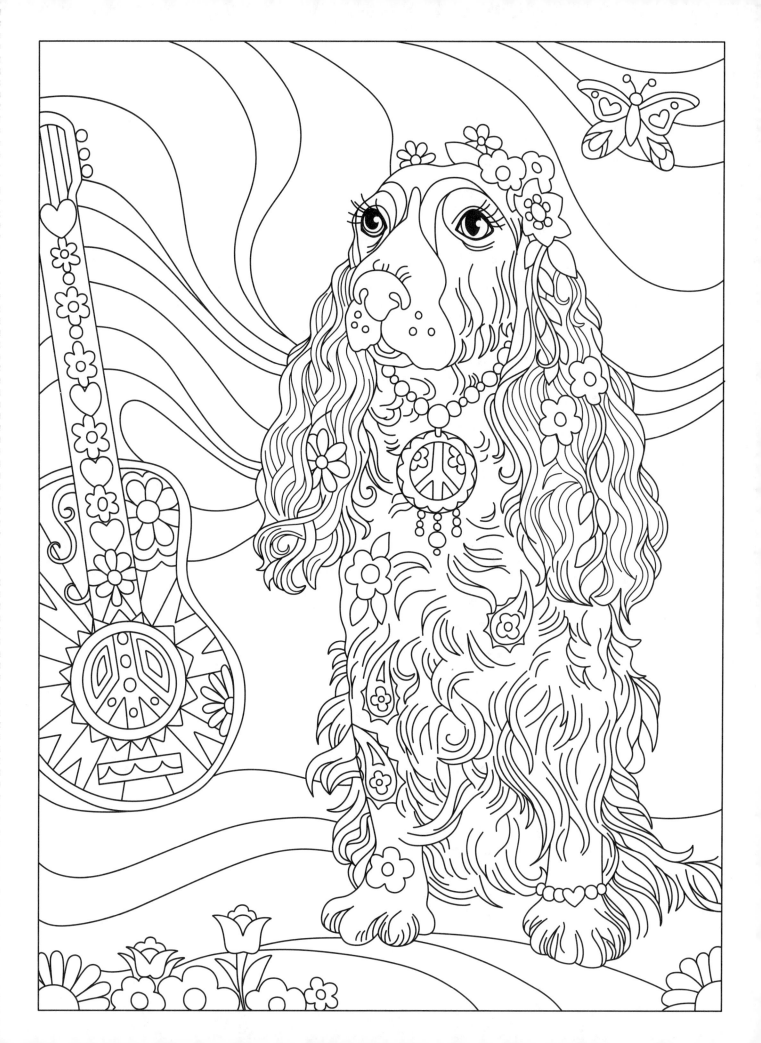

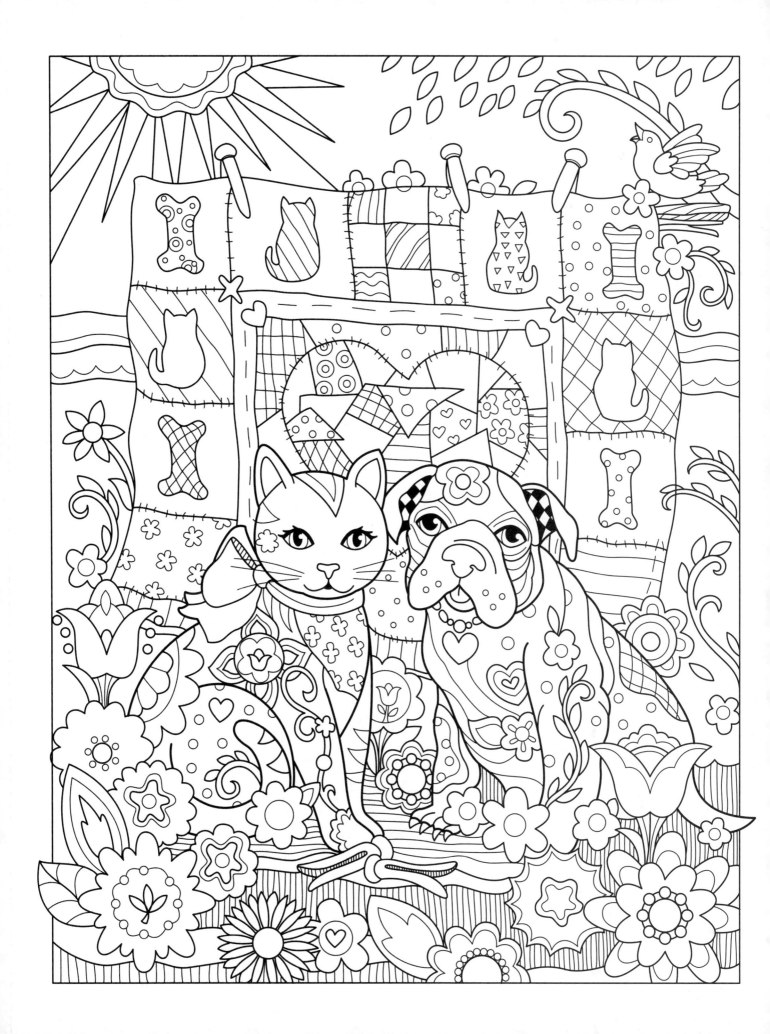

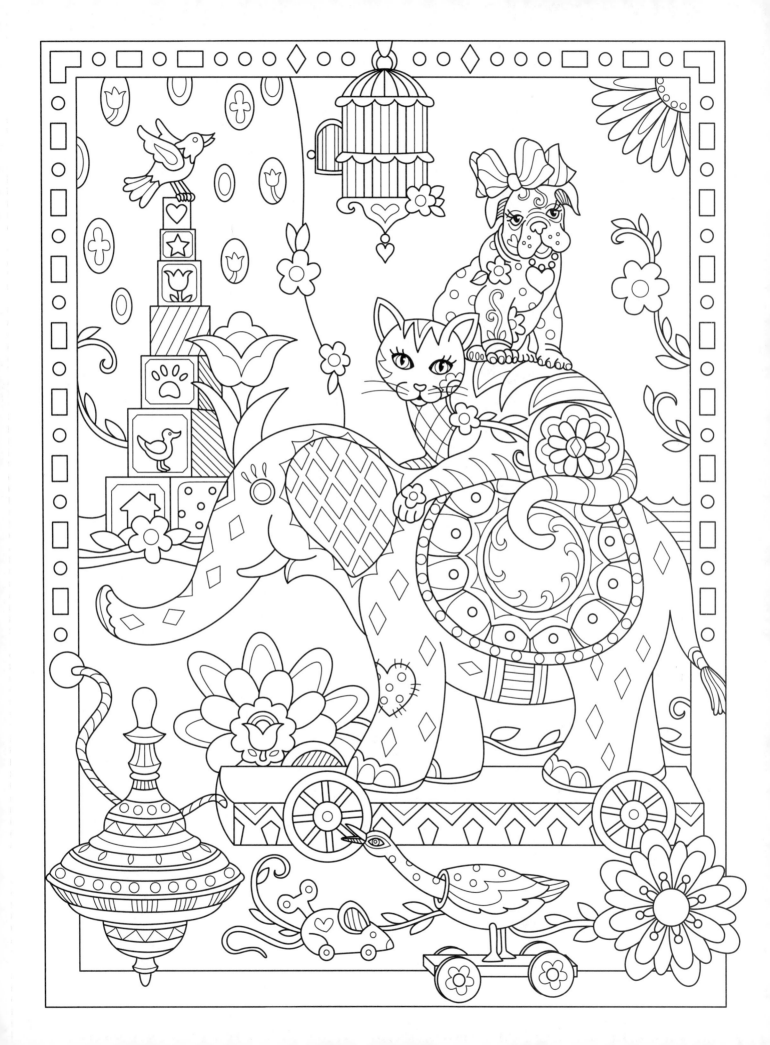

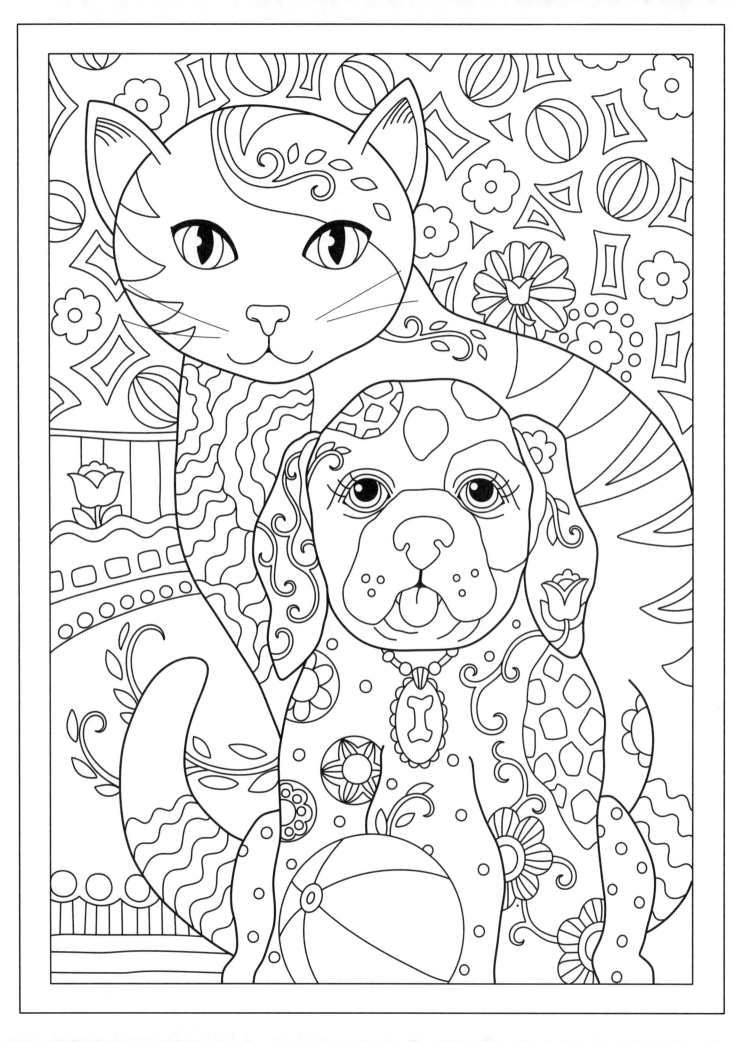

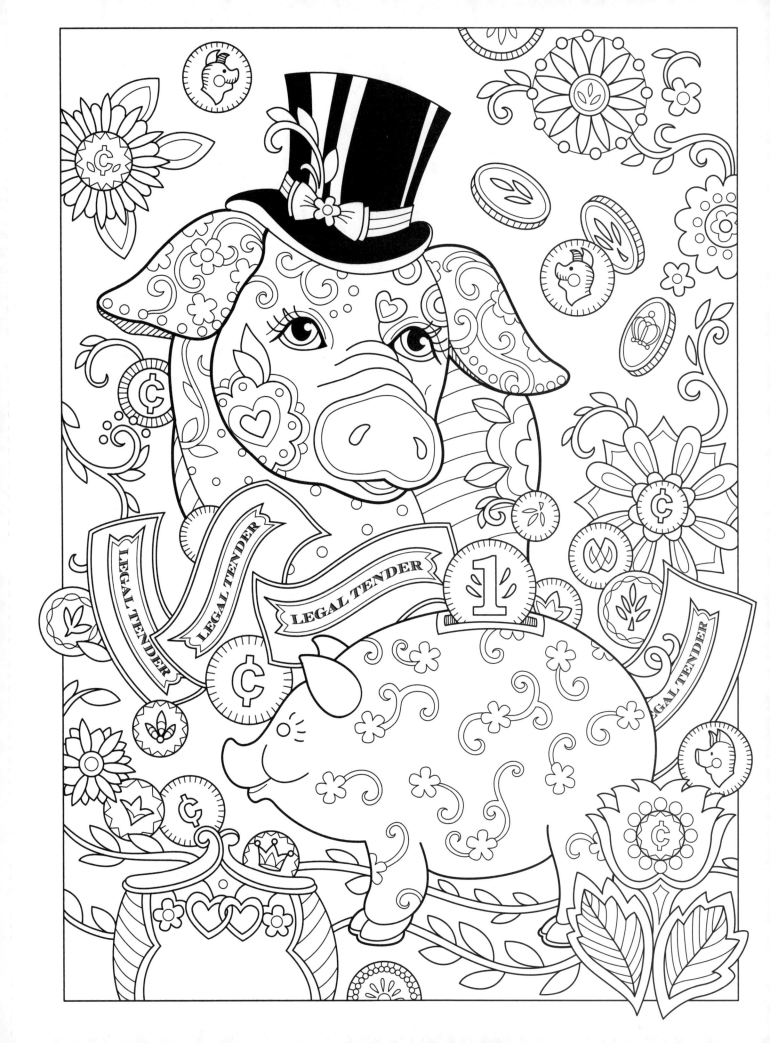

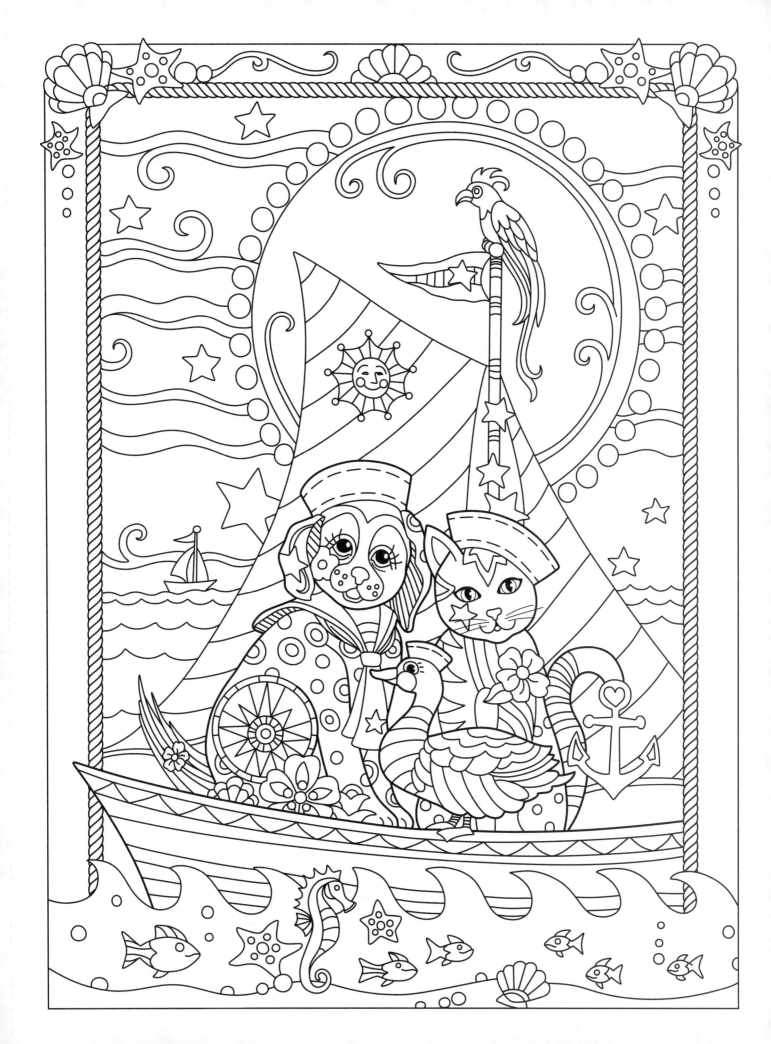

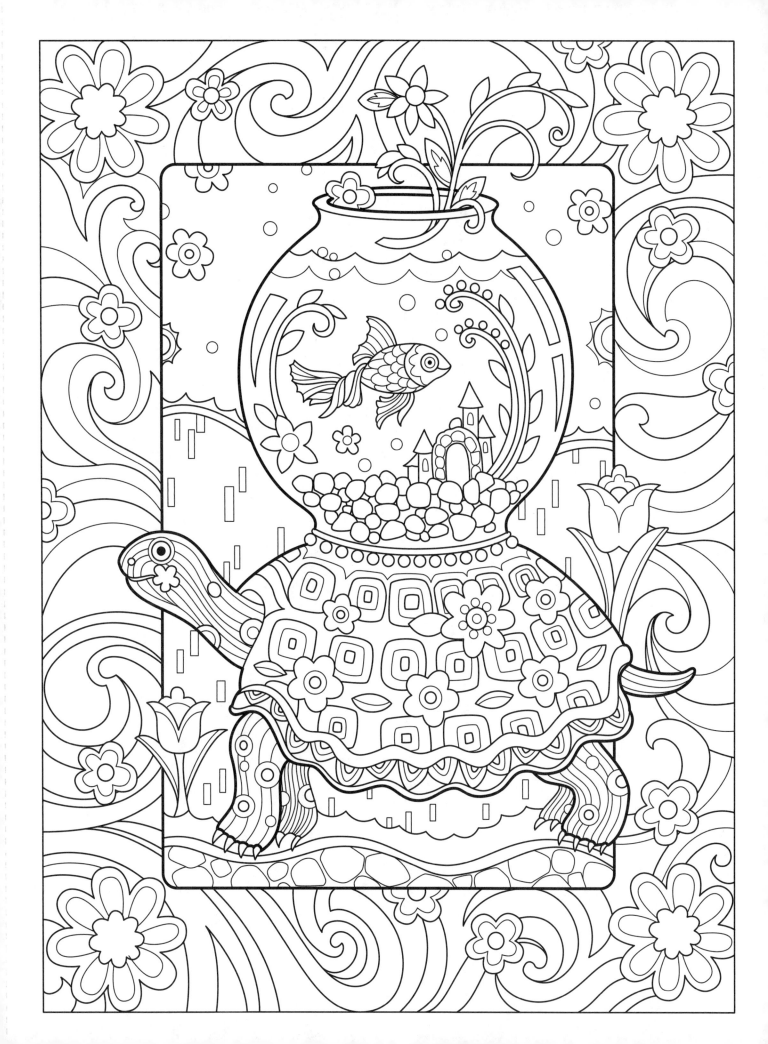

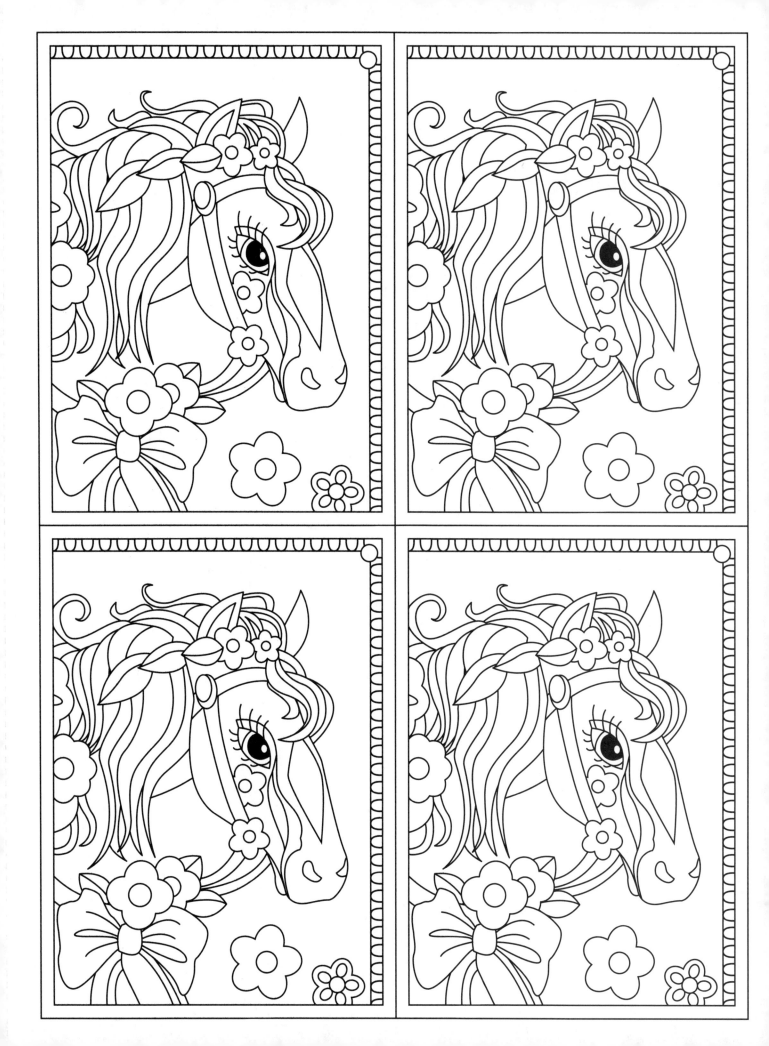

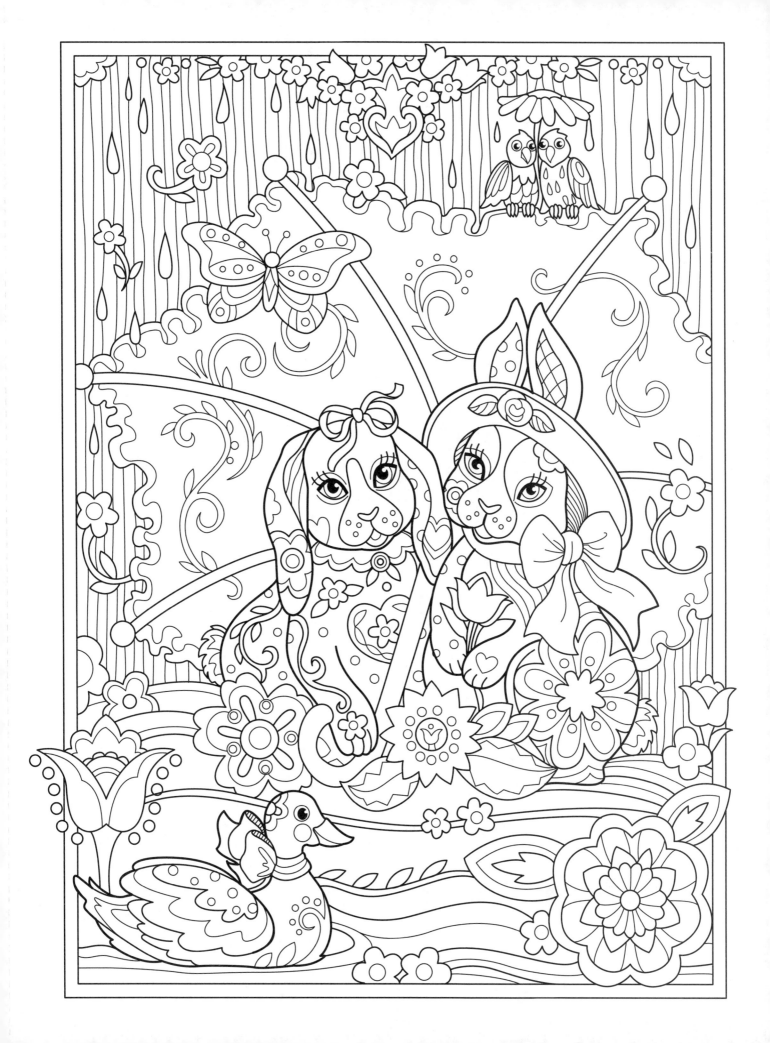

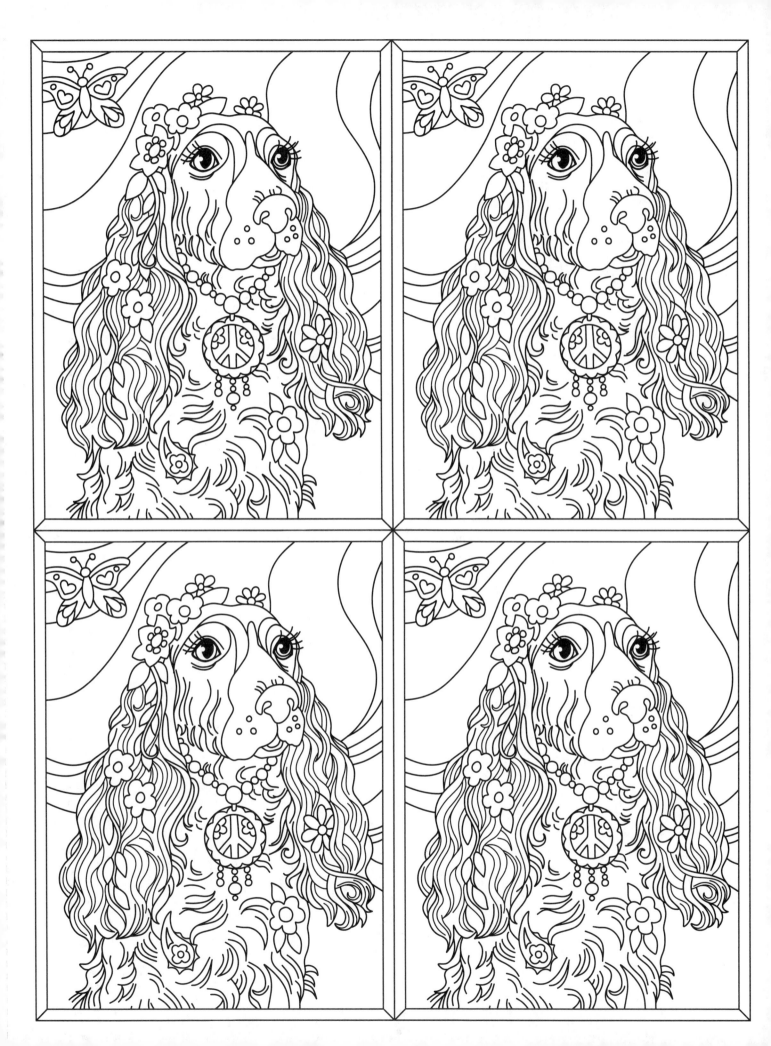

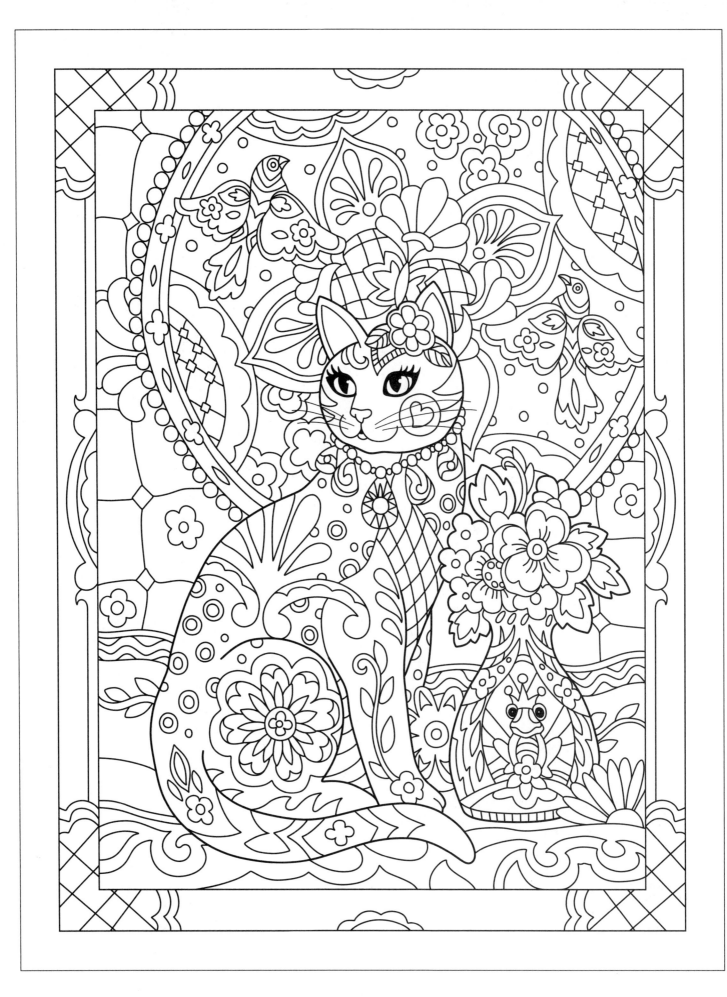

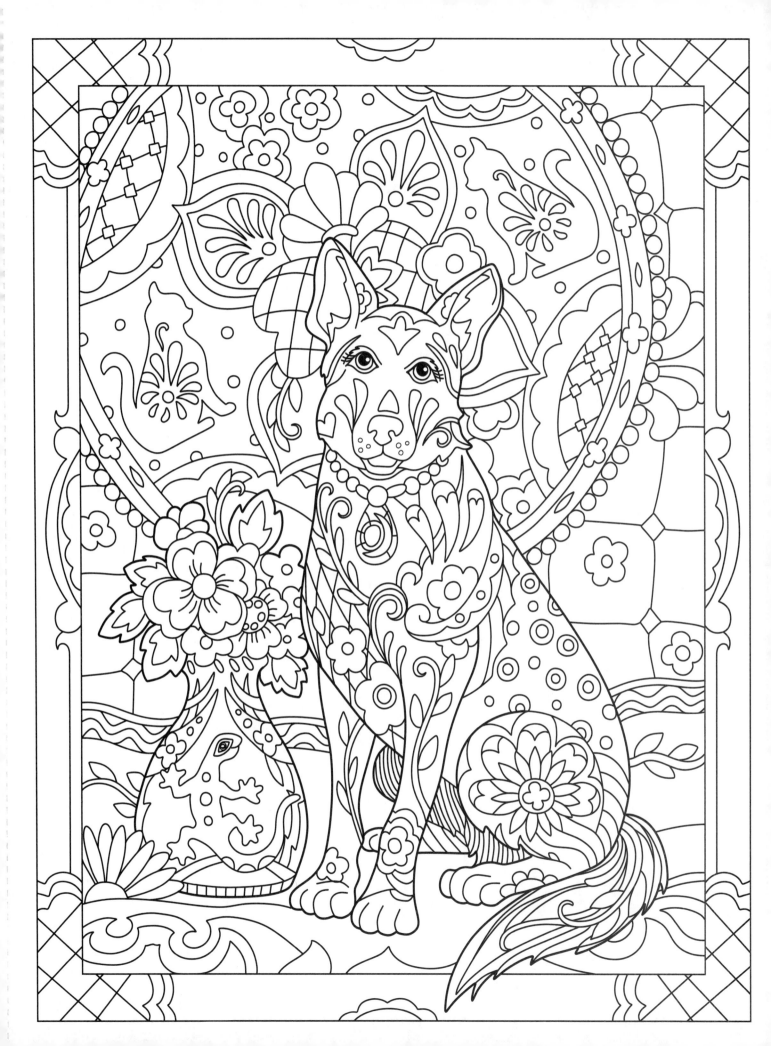

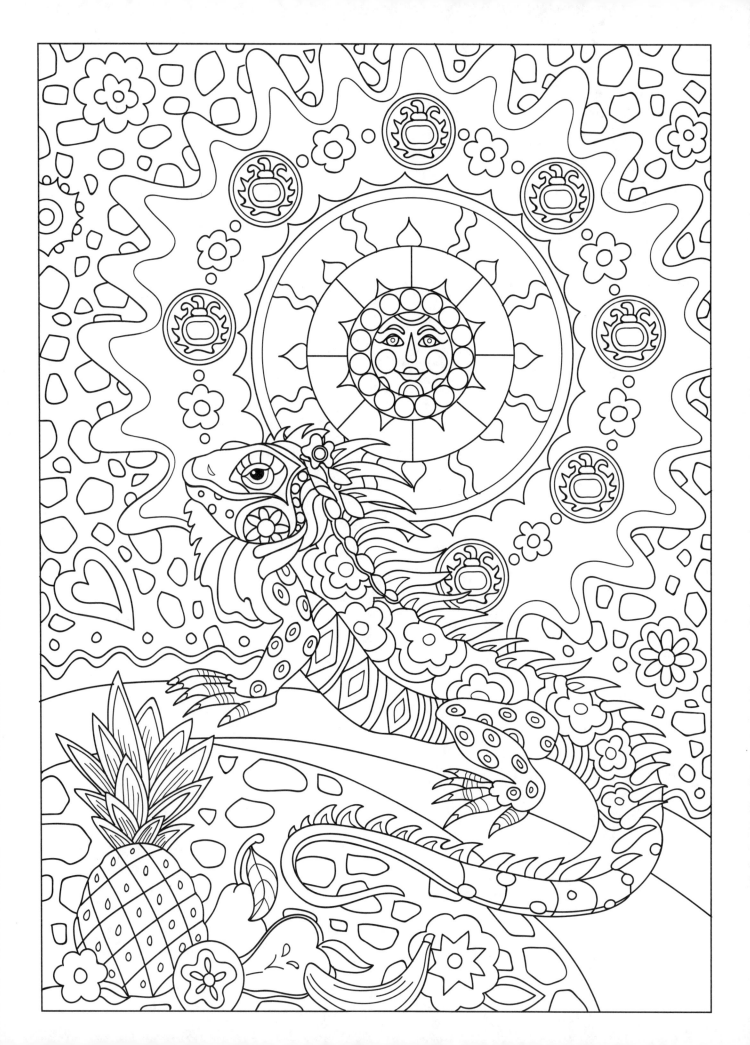

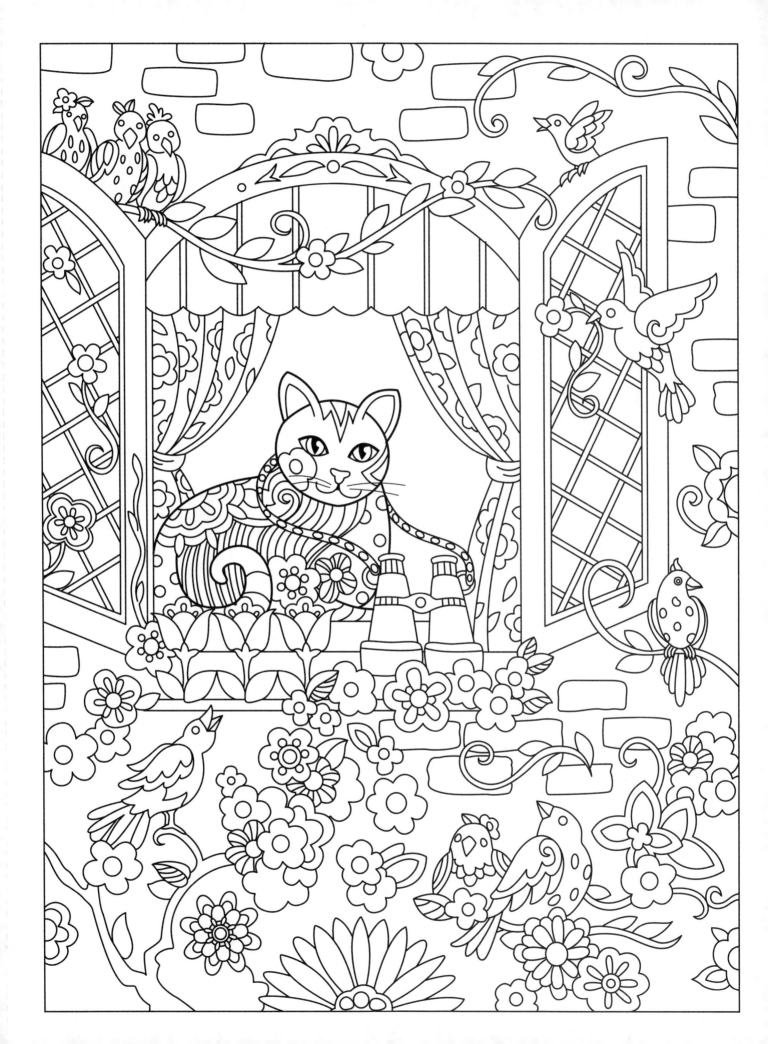

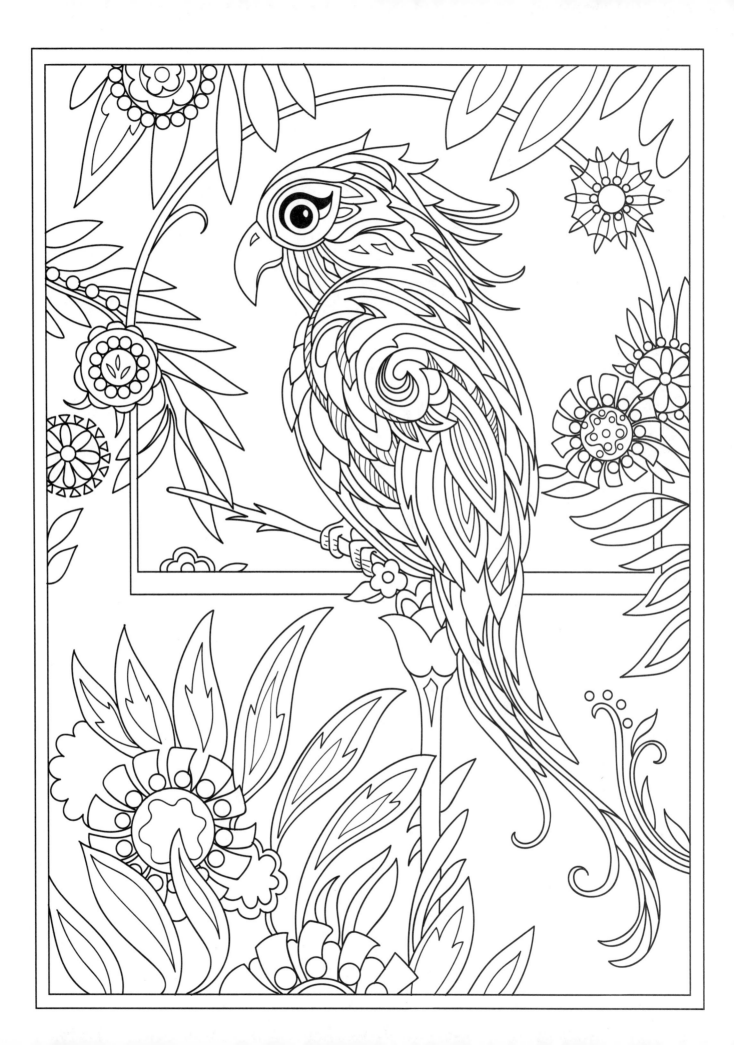

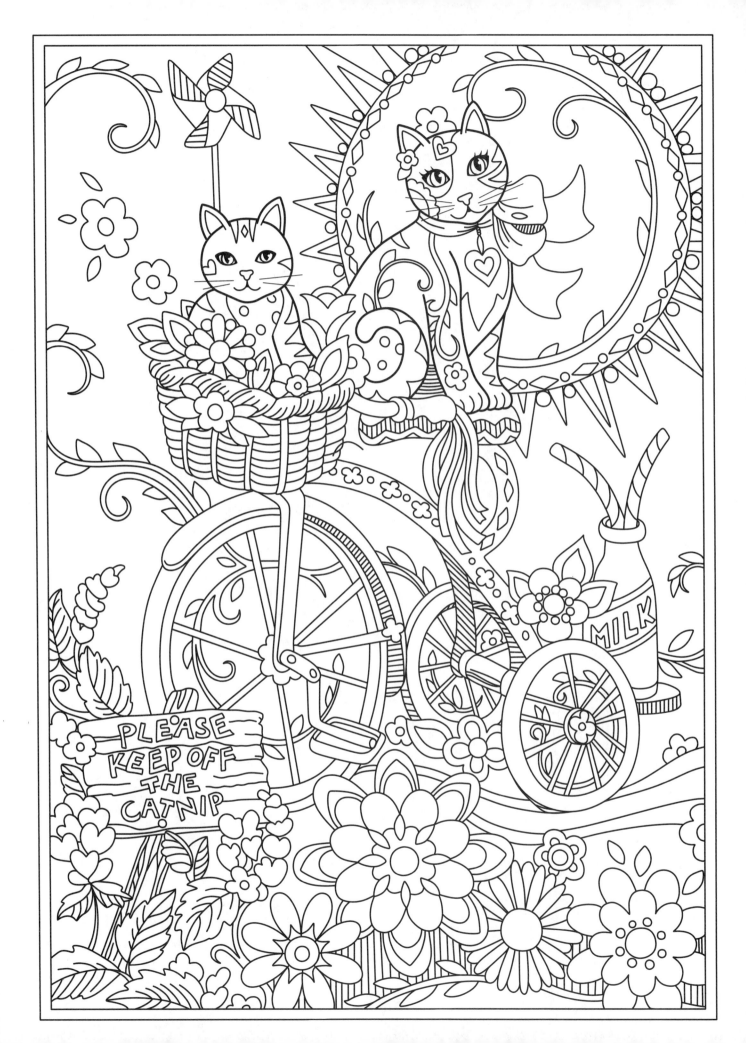

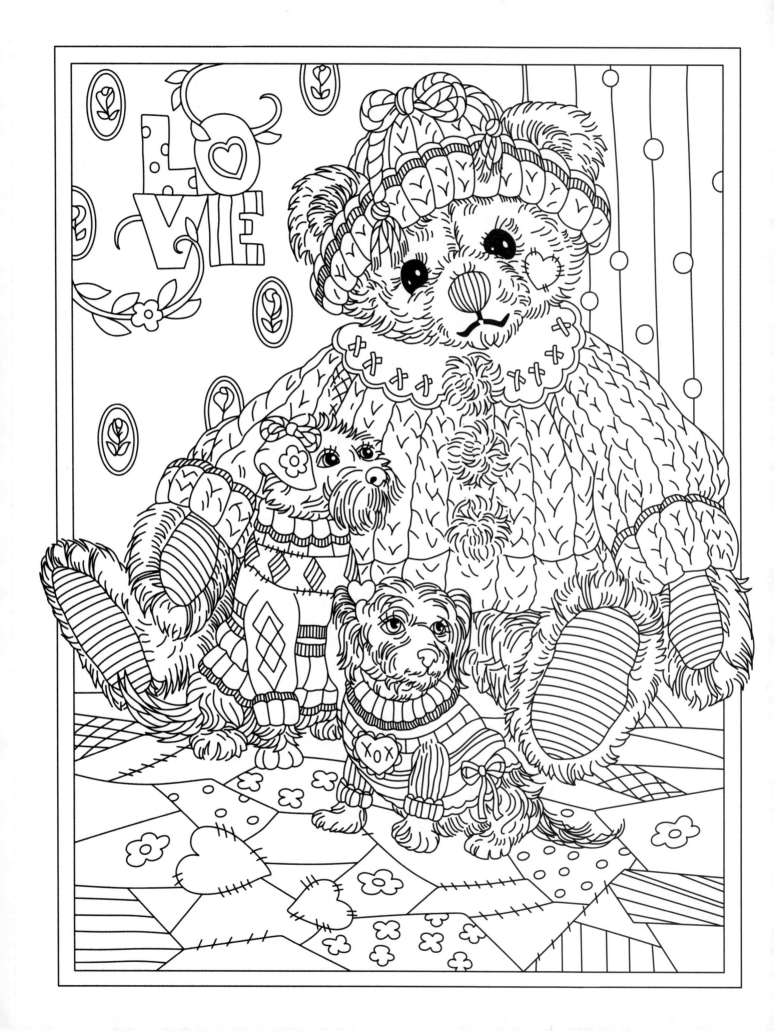

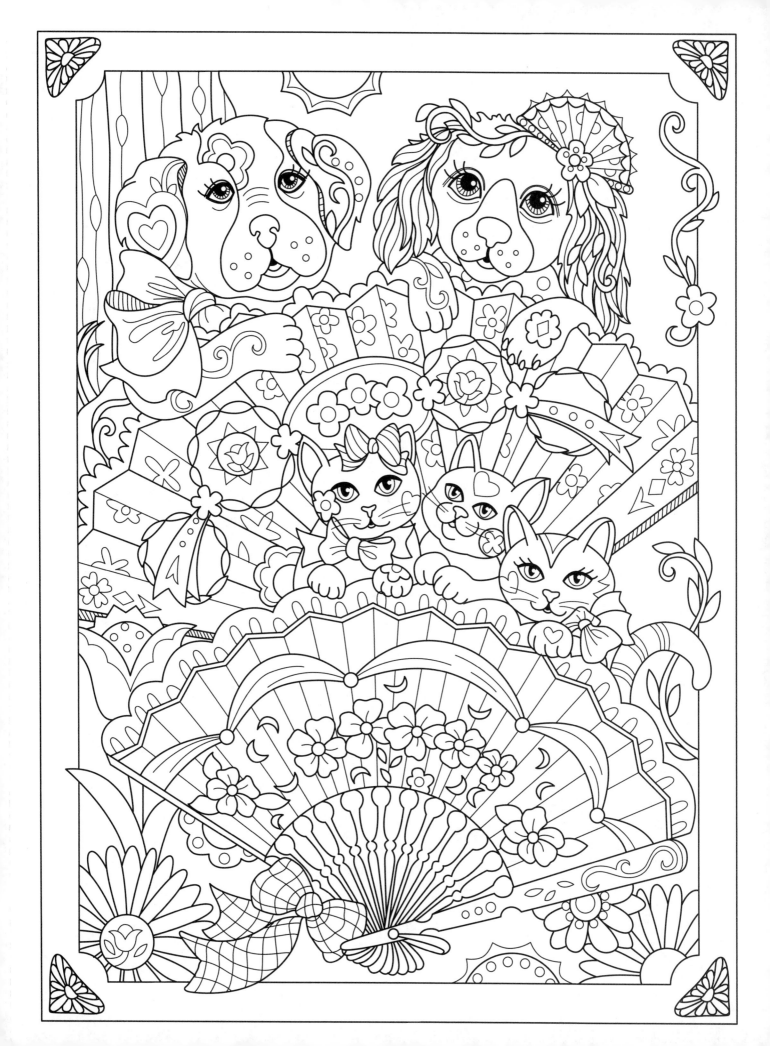

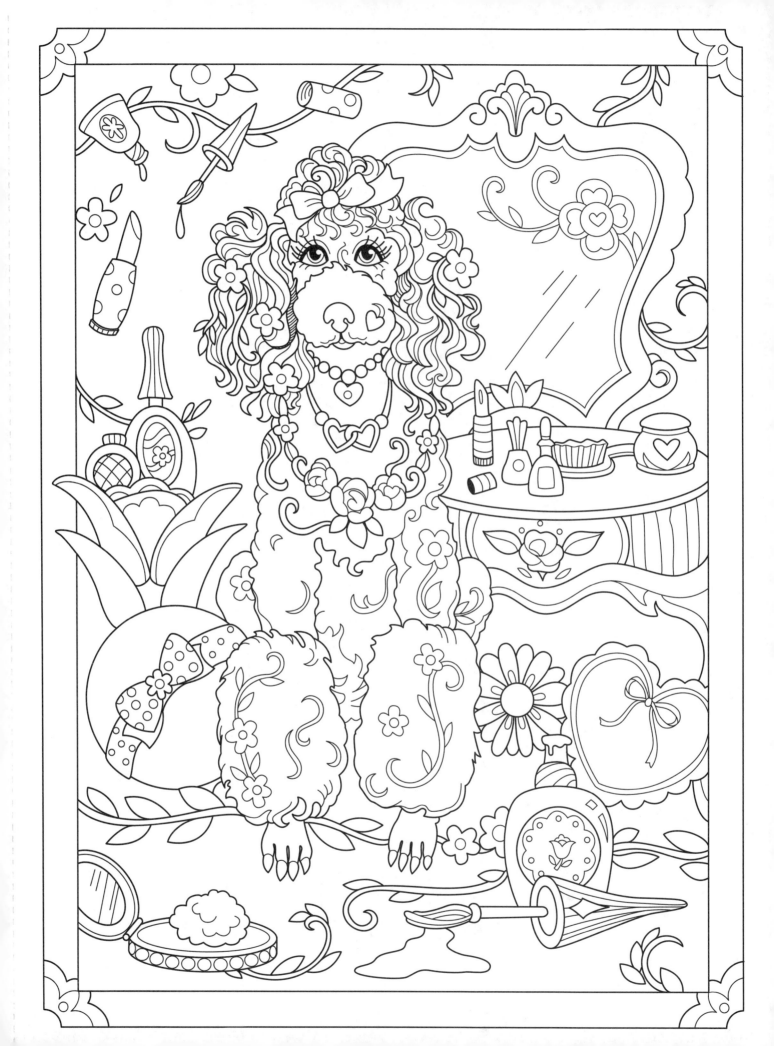

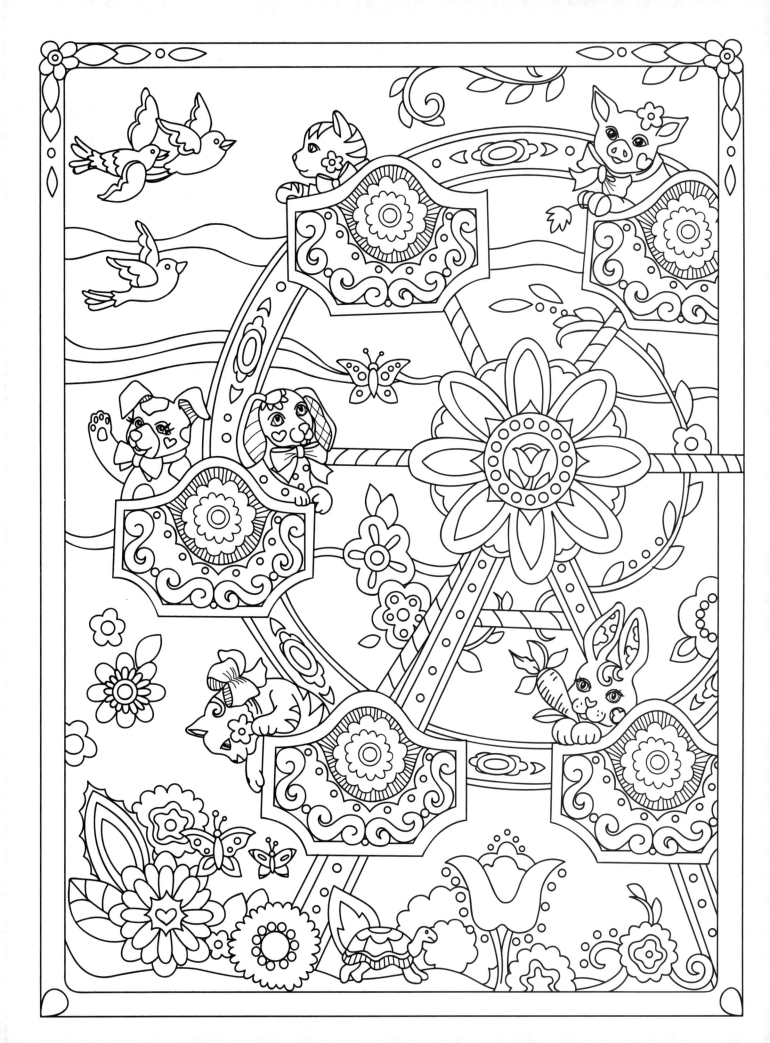

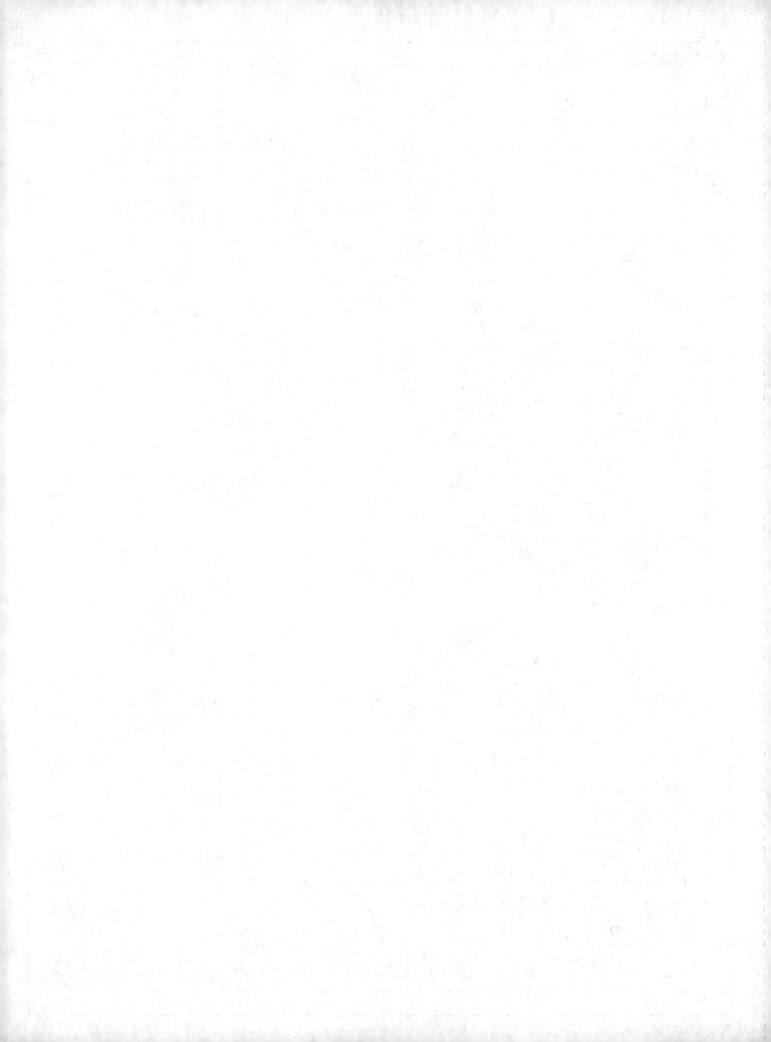

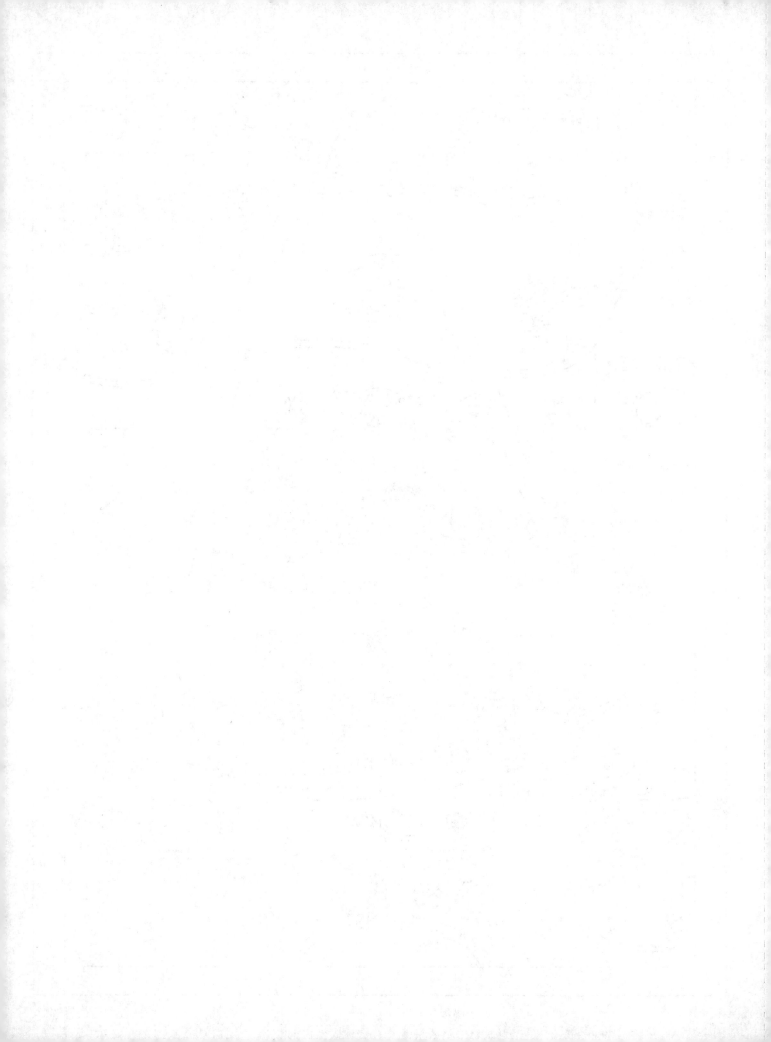

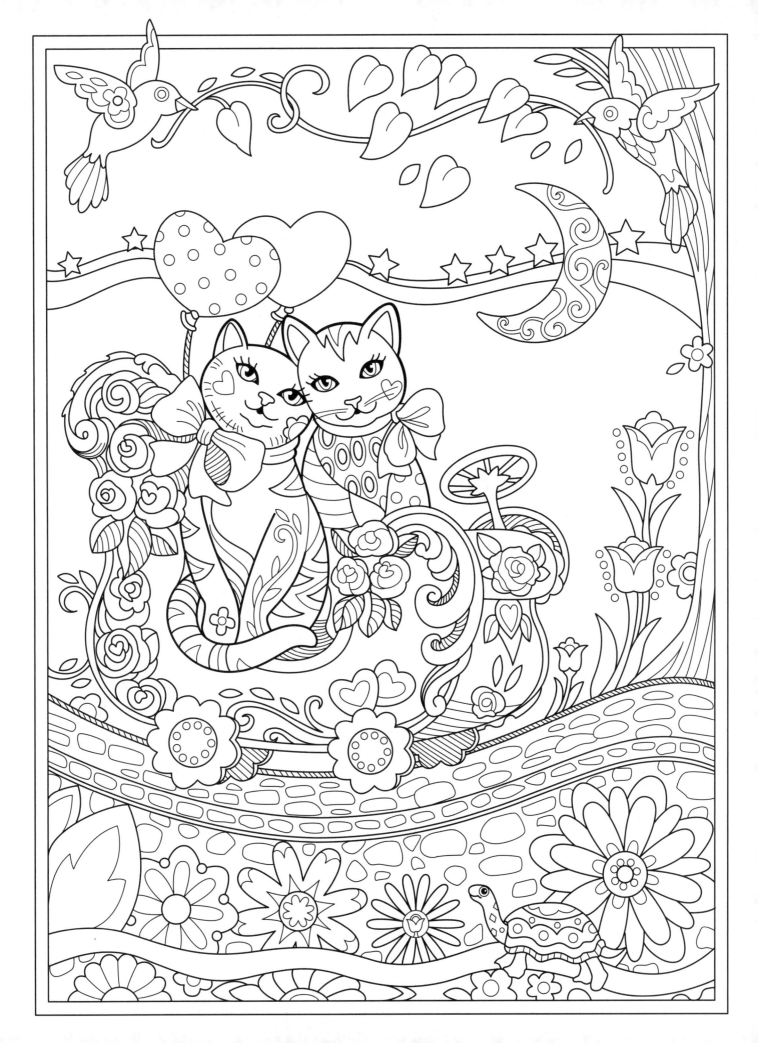

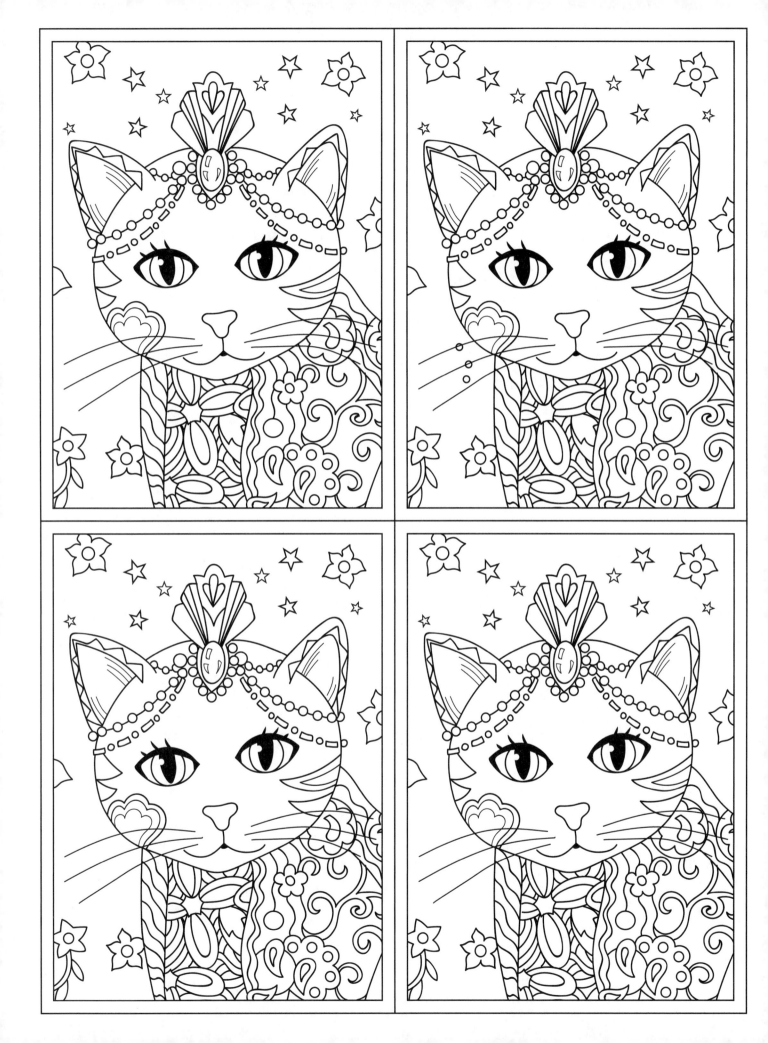

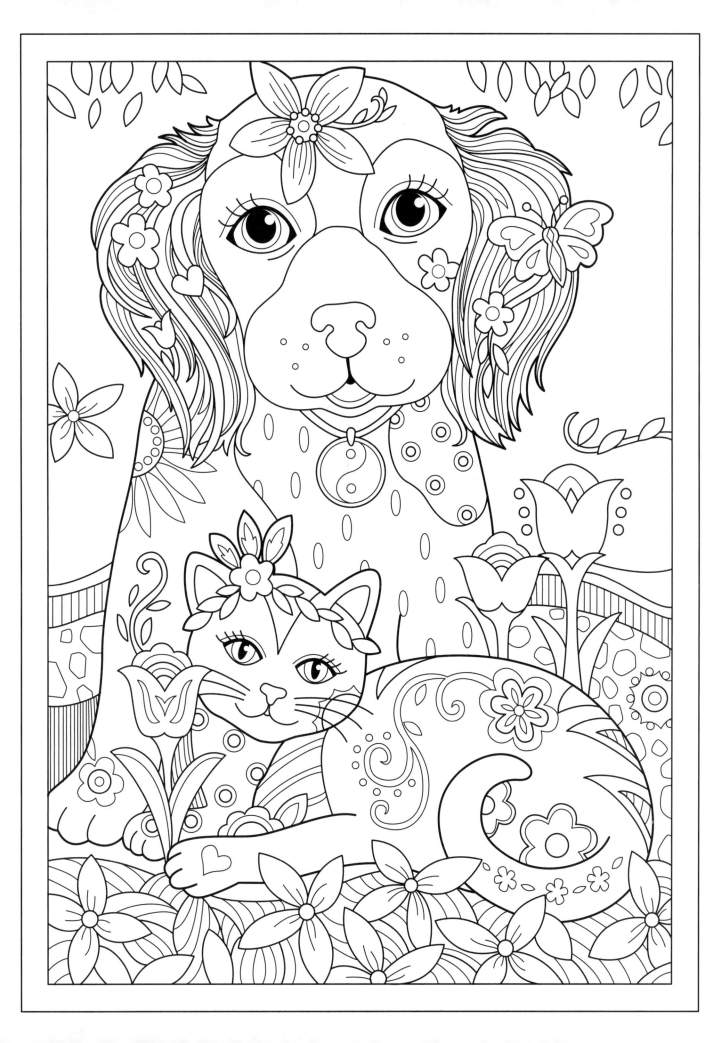

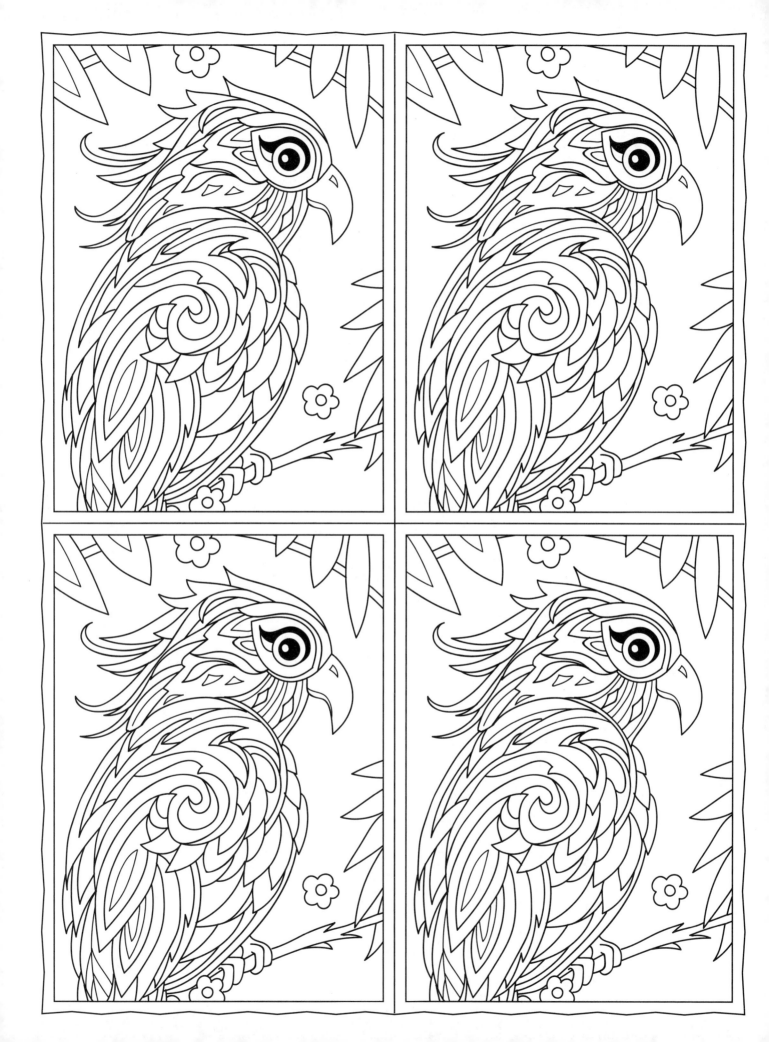

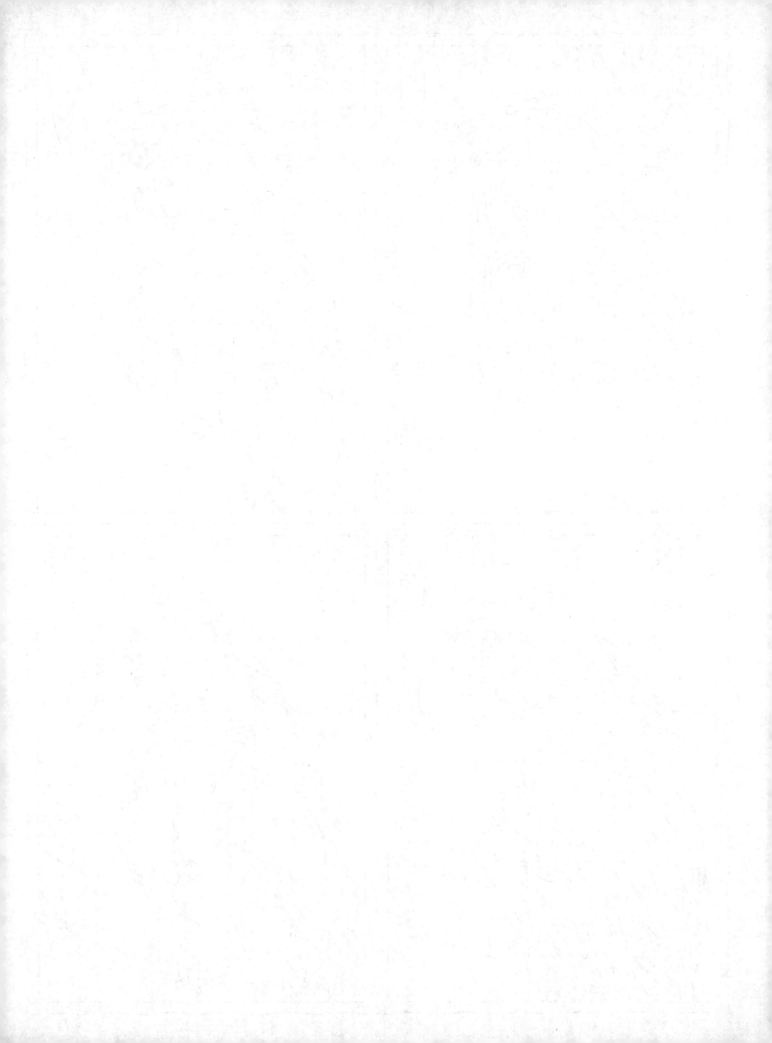

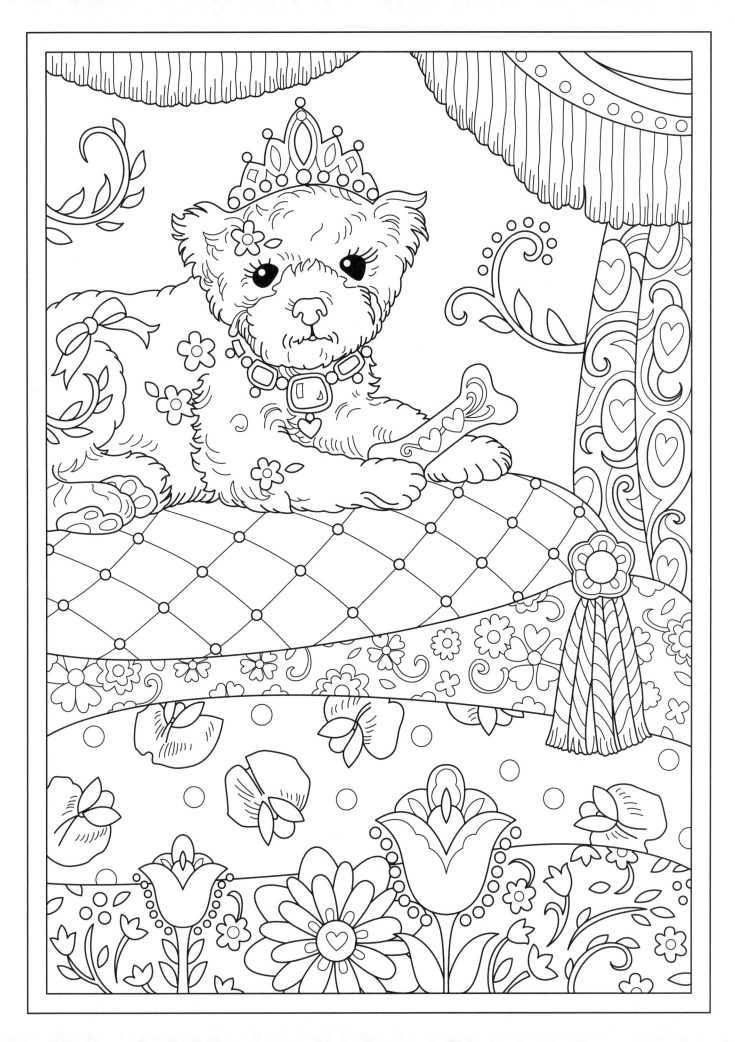

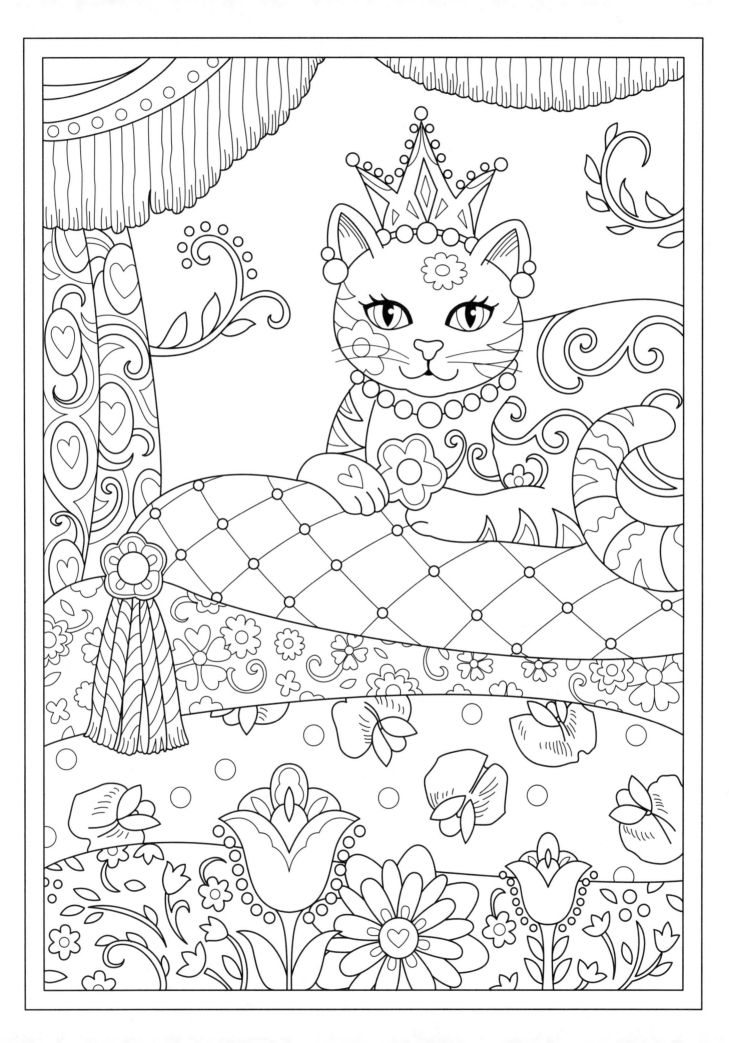

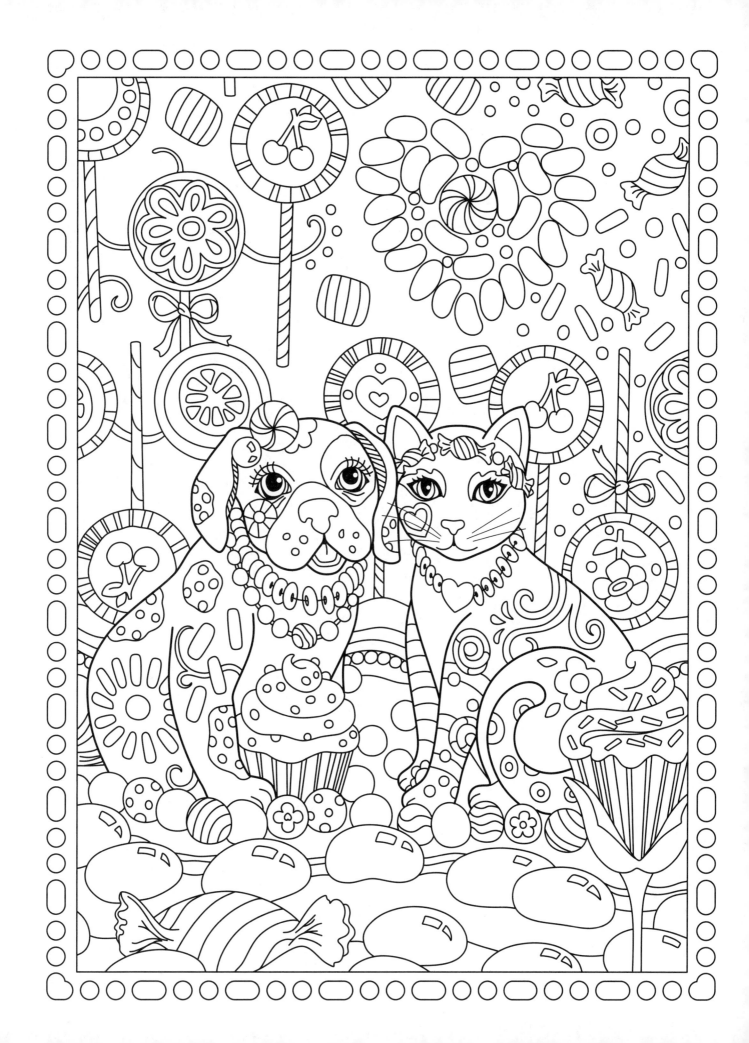

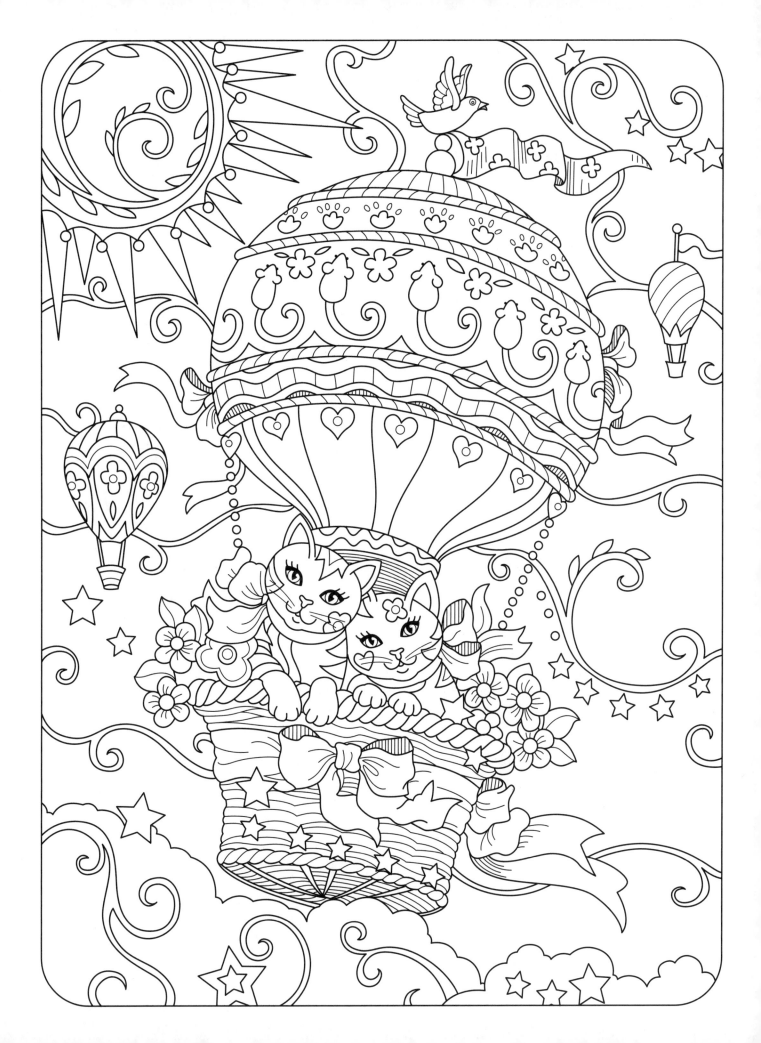

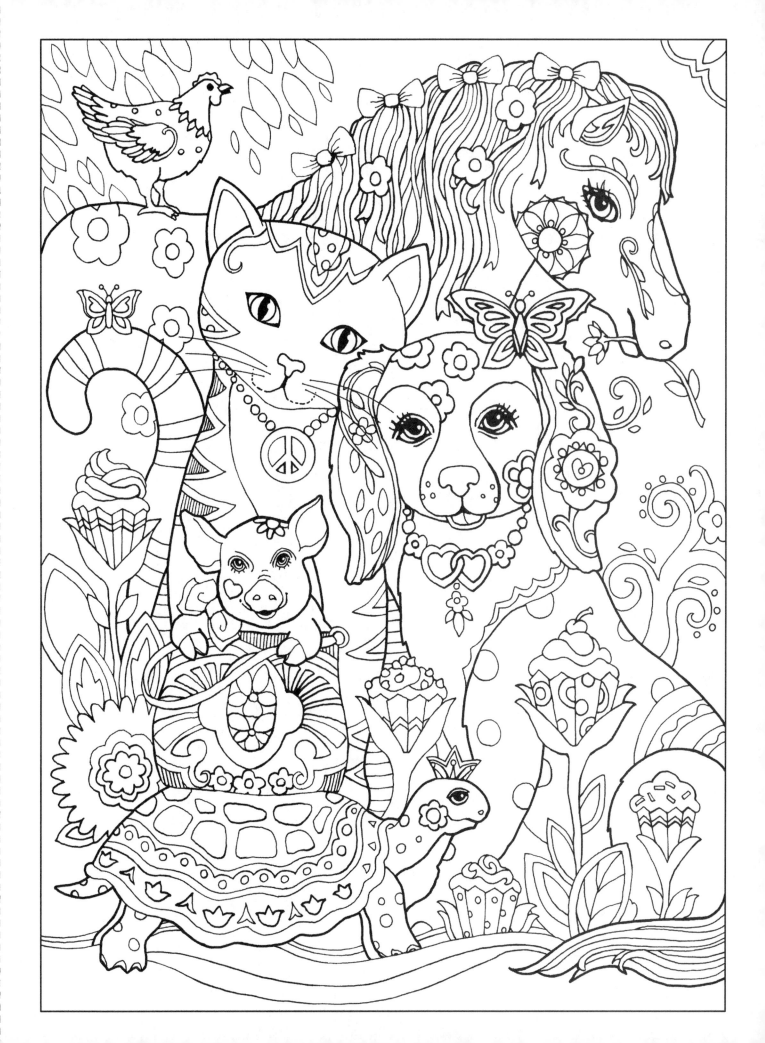

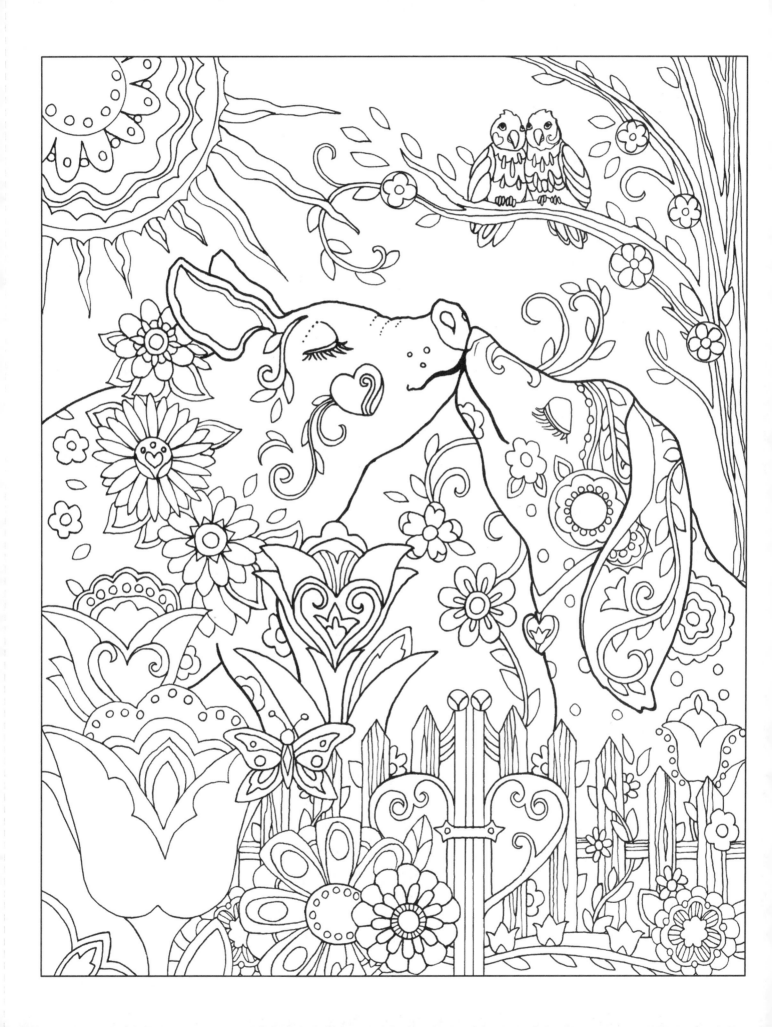

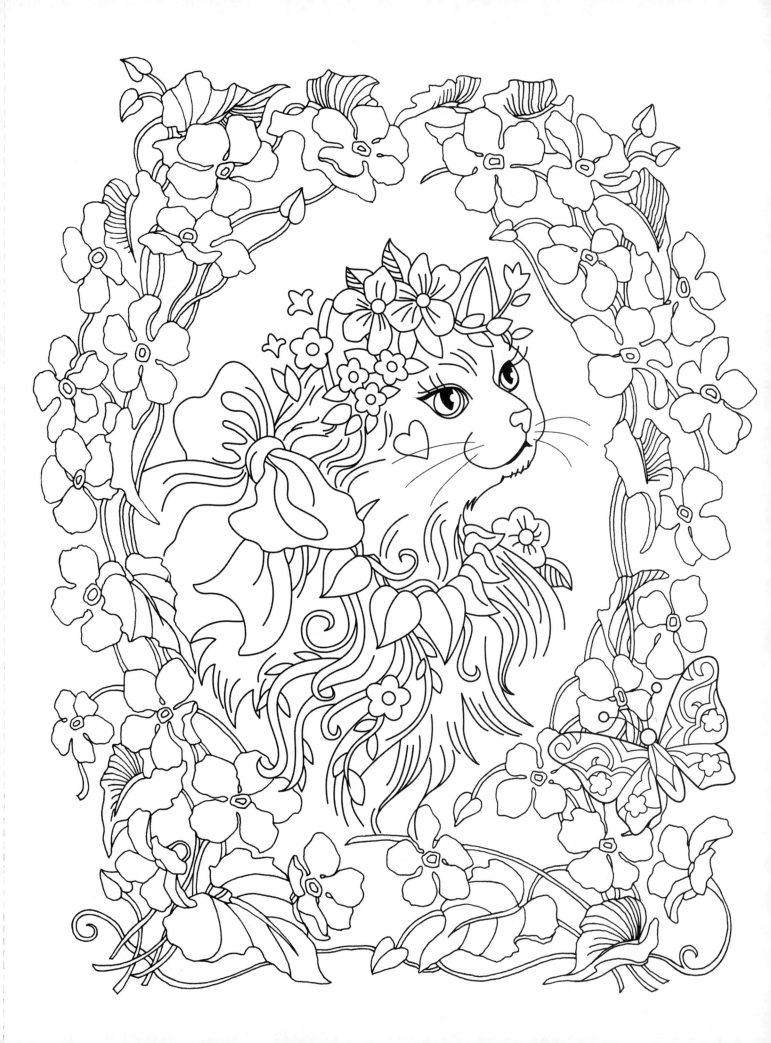

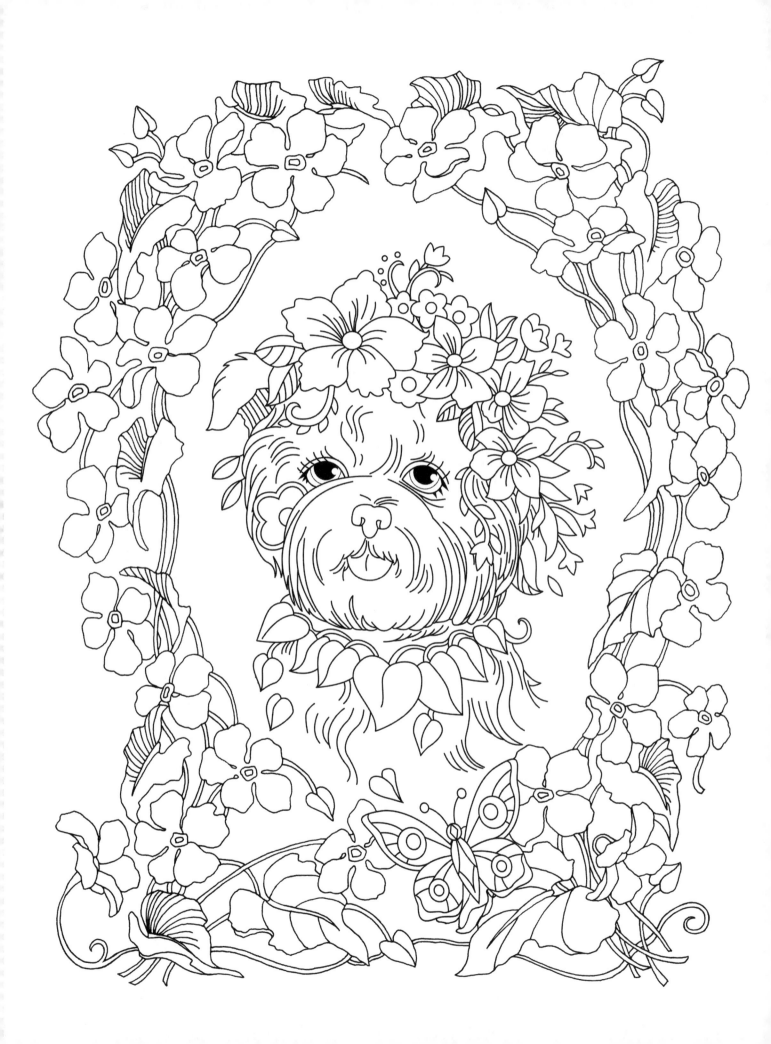

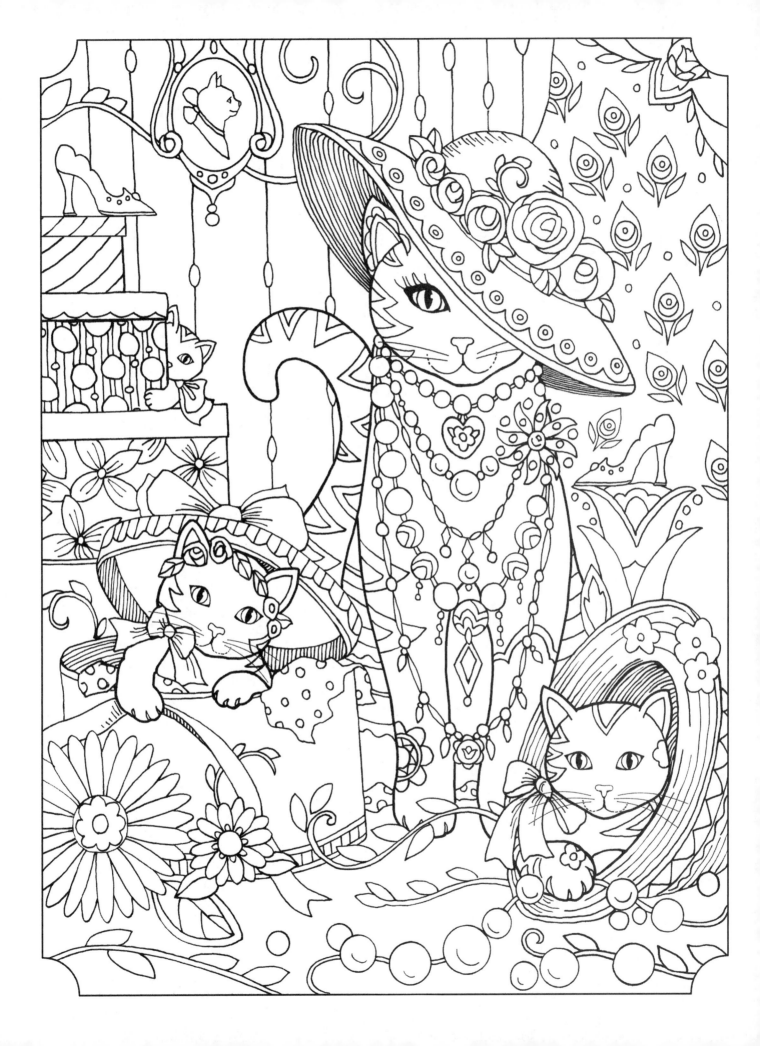

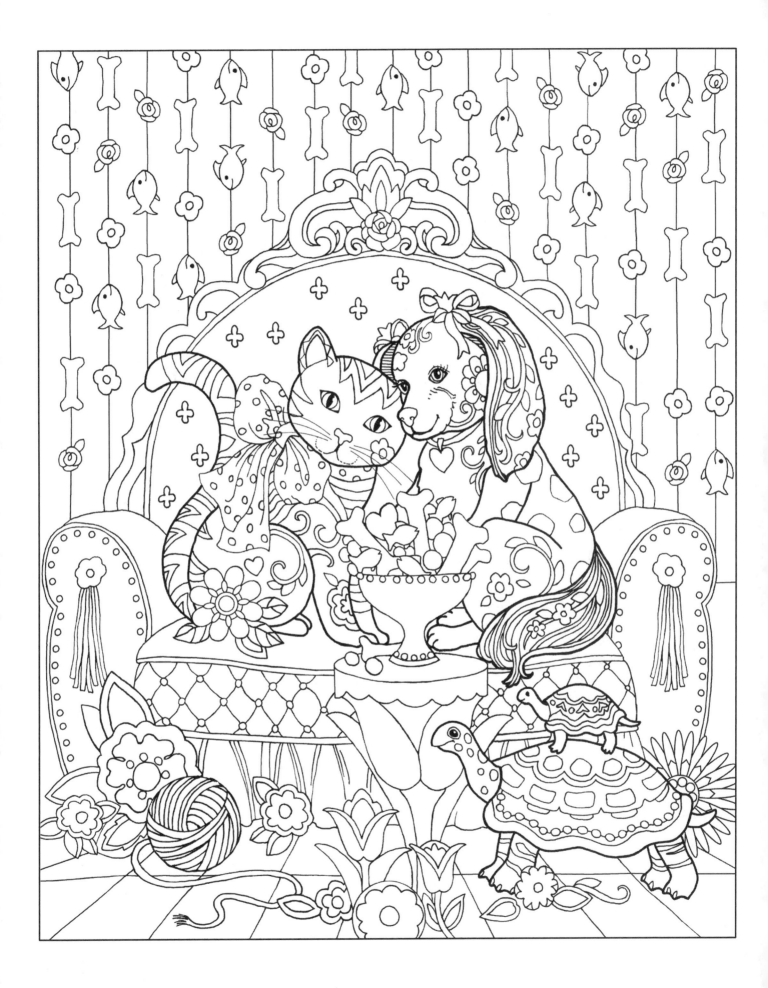

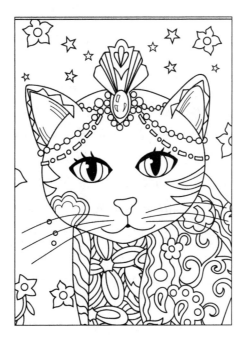

Pets are loved by many people throughout the world. More than eighty million people in the United States alone are pet-owners. Strong bonds are created with these loveable companions—they're members of the family, trusted and cherished confidants. People love to take their pictures, play with them, talk about them, and even dress them up! With a pet, fun is never in short supply.

Animals are also found to be highly relaxing, and are frequently used for therapy purposes, providing affection and comfort to distressed people in hospitals, retirement and nursing homes, hospices, disaster areas, as well as aiding those who have learning difficulties. It has been said that if we see animals in a peaceful state, it can provide us with an impetus for personal change and healing.

Having similar therapeutic properties, the animal kingdom inevitably found its way into the adult coloring book world. This compilation of animal illustrations includes a variety of adorable house pets for you to decorate. Cuddle up with your favorite furry friend and fill these scenes with color!

Ↄↄ

Marjorie Sarnat is a *New York Times* author and illustrator of several coloring books and more than a dozen books on art and creativity. She is also an award-winning mixed-media artist whose works are in collections worldwide. Born and raised in Chicago, Marjorie is an alumna of the School of the Art Institute of Chicago and earned a BFA degree from Eastern Michigan University. Marjorie's fanciful coloring book style evolved from her love of patterns, which she developed through an earlier career as a textile designer. Also influencing her style is her lifelong passion for collecting vintage illustrated books and ephemera. She lives in Granada Hills, California, with her husband, daughter, and son, her two dogs, and her extensive antique book collection.

Also Available from Skyhorse Publishing

Creative Stress Relieving Adult Coloring Book Series
Art Nouveau: Coloring for Artists
Art Nouveau: Coloring for Everyone
Curious Cats and Kittens: Coloring for Artists
Curious Cats and Kittens: Coloring for Everyone
Mandalas: Coloring for Artists
Mandalas: Coloring for Everyone
Mehndi: Coloring for Artists
Mehndi: Coloring for Everyone
Nirvana: Coloring for Artists
Nirvana: Coloring for Everyone
Paisleys: Coloring for Artists
Paisleys: Coloring for Everyone
Tapestries, Fabrics, and Quilts: Coloring for Artists
Tapestries, Fabrics, and Quilts: Coloring for Everyone
Whimsical Designs: Coloring for Artists
Whimsical Designs: Coloring for Everyone
Whimsical Woodland Creatures: Coloring for Everyone
Zen Patterns and Designs: Coloring for Artists
Zen Patterns and Designs: Coloring for Everyone

***New York Times* Bestselling Artists' Adult Coloring Book Series**
Marty Noble's Sugar Skulls: New York Times *Bestselling Artists' Adult Coloring Books*
Marty Noble's Peaceful World: New York Times *Bestselling Artists' Adult Coloring Books*

The Peaceful Adult Coloring Book Series
Adult Coloring Book: Be Inspired
Adult Coloring Book: De-Stress
Adult Coloring Book: Keep Calm
Adult Coloring Book: Relax

Portable Coloring for Creative Adults
Calming Patterns: Portable Coloring for Creative Adults
Flying Wonders: Portable Coloring for Creative Adults
Natural Wonders: Portable Coloring for Creative Adults
Sea Life: Portable Coloring for Creative Adults